CAMBRIDGE INTRODUCTION TO THE HISTORY OF ART

Looking at Pictures

Other titles in the series

Looking at Pictures

SUSAN WOODFORD

*The right of the
University of Cambridge
to print and sell
all manner of books
was granted by
Henry VIII in 1534.
The University has printed
and published continuously
since 1584.*

CAMBRIDGE UNIVERSITY PRESS
Cambridge
New York New Rochelle
Melbourne Sydney

For Peter, who is more than just a good looker

Published by the Press Syndicate of the University of Cambridge
The Pitt Building, Trumpington Street, Cambridge CB2 1RP
32 East 57th Street, New York, NY 10022, USA
296 Beaconsfield Parade, Middle Park, Melbourne 3206, Australia

First published 1983
Reprinted 1987

Printed in Hong Kong by Mandarin Offset
Typeset in Great Britain by SX Composing Ltd

Library of Congress catalogue card number: 82-14613

British Library cataloguing in publication data

Woodford, Susan

Looking at pictures – (Cambridge introduction to
the history of art)
1. Visual perception 2. Pictures
I. Title
152.1′423 BF241
ISBN 0 521 24371 8 hard covers
ISBN 0 521 28647 6 paperback

**This book was designed and produced by
John Calmann and King Ltd, London**

Acknowledgements

For permission to reproduce illustrations the author and publisher
wish to thank the institutions and individuals mentioned in the
captions. The following are also gratefully acknowledged:

59 Colorific, London, and Eddy van der Veen; 1 Cooper-Bridgeman
Library, London; 71 Deutsches Archäologisches Institut, Rome;
31 Werner Forman, London; 21 Giraudon, Paris; 37 Michael Holford,
Loughton; 16, 43, 44, 50, 52, 56, 57, 58, 77, 78, 80, 83, 96, 97, 98
Mansell/Alinari, London and Florence; 5, 9, 17, 18, 67, 86, 91
Réunion des Musées Nationaux, Paris; 2, 75, 79, 82 Scala, Florence;
65 © Vaga, New York; 23 Victoria and Albert Museum, London

Acknowledgement is also due to the following for permission to quote
excerpts from works published by them: Penguin Books Ltd for
passages quoted from the E.V. Rieu translation of the Gospels, and for
a passage from Ovid's *Metamorphoses*, translated by Mary M. Inness;
Harvard University Press for a piece from R. Magurn, *The Letters of
Rubens*; Random House for a piece from Jowett's *Complete Works of Plato*.

Contents

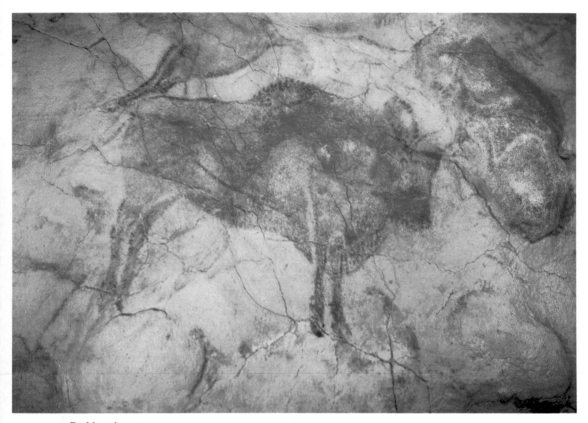

1 Prehistoric cave
painting of a bison,
Altamira, Spain.
15,000–10,000 BC

1 Ways of looking at pictures

There are many ways of looking at pictures. In this chapter let us take four pictures, widely separated in time and style, and look at them in a number of quite different ways.

We can begin by asking ourselves what purpose a picture served. This lively and convincing picture of a bison (Fig.1) was painted some 15,000 years ago on the ceiling of a cave in what is now Spain. What, we might wonder, was the function of this beautiful and vivid painting, placed in a dark recess a little way from the entrance of the cave? Some think its purpose may have been a magic one, and that the image was supposed to enable its maker (or his tribe) to trap and kill the animal depicted. We find a similar principle in voodoo, where a pin stuck into a doll made to resemble a person is supposed

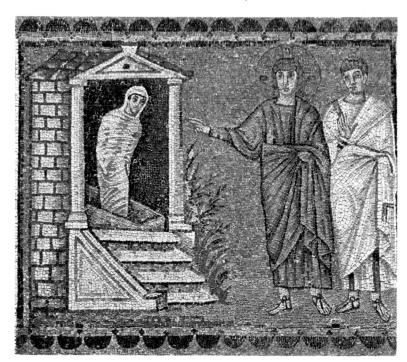

2 *The Raising of Lazarus.*
Mosaic, sixth century.
S. Apollinare Nuovo,
Ravenna

to injure the person represented. The cave painter may have hoped that capturing the image of the bison in the cave would lead to the capture of the bison itself.

The second picture (Fig.2) is very different; it is a mosaic from an early Christian Church. Its subject, the raising of Lazarus, is easy for us to identify. Lazarus had been dead for four days when Jesus arrived, but Jesus had the tomb opened, and then, according to the gospel of St John, he

'raised his eyes to Heaven and said: "Father . . . I act for the sake of these people standing round me, so that they may believe that thou didst send me here."
'Then he cried in a loud voice: "Lazarus, come out." And the dead man came out, wrapped hand and foot in grave-clothes . . .'

John 11:41–44

The picture illustrates the story with wonderful clarity; we see Lazarus 'wrapped hand and foot in grave-clothes' emerging from the tomb in which he was buried. We see Jesus, clad in royal purple, calling Lazarus forth with an eloquent gesture. Beside him one of the 'people standing round', for whose benefit the miracle was performed, raises his hand in astonishment. The picture is arranged very simply with flat, clearly defined figures shown against a gold background. It is not as lively as the cave painting, but it makes the story immediately recognisable to those who know it.

What purpose did this picture serve as part of the decoration of a church? At the time this mosaic was created, in the sixth century, few people could read. Nevertheless the Church was anxious that as many as possible should learn the teachings of the gospels. As Pope Gregory the Great explained, 'Pictures can do for the illiterate what writing does for those who can read' – that is, simple people could find out about the Holy Scriptures from looking at such easily comprehended illustrations as this one.

Now look at an oil painting from the brush of the sophisticated sixteenth-century painter Bronzino (Fig.3). He has depicted the pagan goddess of love, Venus, embraced in a very erotically suggestive way by her son, the winged youth Cupid. To the right of the central group we see a happy little boy who, according to one scholar, represents Pleasure. Behind him there is a strange girl in green, whose body, we note with surprise, emerges from beneath

her dress in the form of a coiled serpent. She probably represents Deceit, an unpleasant quality – fair-seeming above, but ugly under the surface – which frequently accompanies love. To the left of the central group we see an angry old hag, tearing her hair. She is Jealousy, that combination of envy and despair that also often accompanies love. At the top we see two figures who are raising a curtain that apparently had covered the scene. The man is Father Time, winged and bearing his symbolic hour-glass on his shoulder. It is Time that reveals the many complications that beset the lustful sort of love shown here. The woman opposite him on the left is thought to be Truth; she unmasks the awkward combination of terrors and joys that are inseparable from the gifts of Venus.

The picture therefore conveys a moral maxim: jealousy and deceit can be just as much the companions of love as pleasure is. But this moral is not conveyed simply and directly, as is the story of the raising of Lazarus (Fig.2); it is embodied instead in a complicated and obscure allegory involving what are called *personifications*. The purpose of this picture was not to tell a story lucidly for the illiterate but to intrigue and to some extent tease a highly literate and knowledgeable audience. It was made for the Grand Duke of Tuscany and given by him to François I, the King of France (see Figs.17 and 18). This was a painting, then, designed for the amusement and edification of a cultured few.

Lastly, let us look at a picture made in our own time, a work by the American painter Jackson Pollock (Fig.4). It shows no recognisable part of the ordinary world – no bison to be captured, no religious story to be conveyed, no complex allegory to be unravelled. What it does instead is record the action of the painter himself as he hurled paint onto the enormous canvas to create this exciting and animated abstract pattern. What is the purpose of such a work? Its intention is to reveal the creative activity and downright physical energy of the artist, to inform the observer of the action of his body as well as his mind when he undertakes the labour of producing a painting.

A second way of looking at pictures is by asking what they tell us about the cultures in which they were produced. Thus the cave painting (Fig.1) can tell us (obscurely enough, to be sure) something about the early men who moved about from place to place, some-

9

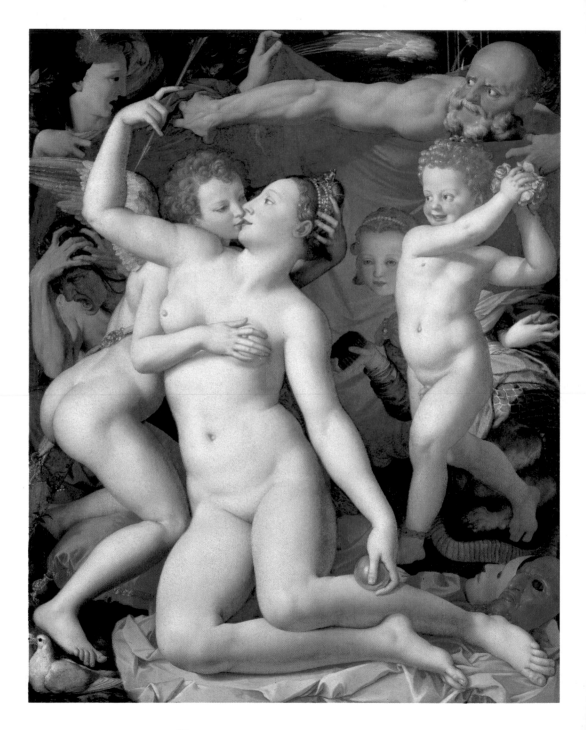

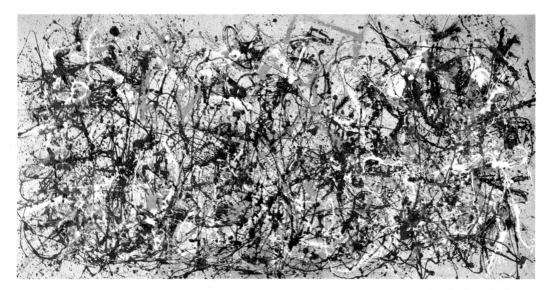

3 *Left* Agnolo Bronzino (Italian, 1503–72): *Allegory* (called *Venus, Cupid, Folly and Time*), c.1546. 57½ × 45½ins (146 × 116cm). National Gallery, London

4 *Above* Jackson Pollock (American, 1912–56): *Autumn Rhythm*, 1950. 105 × 207ins (267 × 526cm). Metropolitan Museum of Art, New York (George A. Hearn Fund, 1957)

times sheltering in caves, who hunted wild animals but built no permanent houses and grew no crops.

The sixth-century Christian mosaic (Fig.2) reflects a paternalistic culture in which the enlightened few provided instruction for the uneducated masses. It tells us that in the early days of Christianity it was important to convey holy stories to the people as clearly as possible so that they could absorb the meaning of this relatively new religion.

Bronzino's painted allegory (Fig.3) speaks volumes about an intellectually refined, perhaps even jaded, courtly society that loved riddles and puzzles and used art to play sophisticated games with.

The twentieth-century painting (Fig.4) tells us something about people living in an age that cherishes an individual artist's personal vision or unique action, an age that seems to reject the traditional values of the privileged classes and encourages artists to express themselves freely and originally.

A third way to look at pictures is to ask how realistic they are. Resemblance to nature has often been an important and challenging consideration for artists, particularly during classical antiquity (from about 600 BC to 300 AD) and from the time of the Renaissance (starting in the fifteenth century) up to the beginning of the twentieth century. Making pictures look convincingly real presents fascinating problems, and many generations of artists worked with great imagination and application to solve them. But this concern was not always uppermost in an artist's mind. Often it is irrelevant to apply our own standard of naturalistic achievement to a picture,

for this may not have been the standard towards which the artist himself was working. For instance, the medieval mosaicist who wanted to tell a bible story as vividly as possible (Fig.2) did not make his figures seem as rounded and natural as, for instance, Bronzino (Fig.3), but he did make the main figures of Christ and Lazarus easily recognisable and placed Christ's significant gesture in the centre of the picture, isolated against the background. Clarity was what he sought above all else; he shunned even a hint of ambiguity, and the complexity and confusion of what we consider natural appearances might have seemed to him only a distraction.

Similarly, the modern artist who created Fig.4 and sought to express himself in paint so vigorously should not be judged in terms of any resemblance to nature, with which he was not in the least concerned. He aimed to convey some aspect of his feelings and had no desire to record his visual surroundings.

Thus although we are often entitled to ask how much a picture resembles reality, we must be careful not to do so when the question may be irrelevant.

A fourth way to look at pictures is by thinking about them in terms of design – that is, the way forms and colours are used to produce patterns within the picture. For instance, if we look at Bronzino's *Allegory* (Fig.3) in this way, we can see that the main group of figures, Venus and Cupid, forms a pale-coloured 'L' that follows the shape of the frame of the picture. Next we notice that the painter has balanced this 'L'-shaped group by another, this time inverted, 'L' formed by the figure of the little boy representing Pleasure together with the head and arm of Father Time. These two 'L's form a rectangle which anchors the representation firmly within the frame; and the stability of the otherwise highly complex composition is thereby assured.

Now look at other aspects of the design. Notice that the entire space is filled with objects or figures; there is no place for the eye to rest. This restless activity of forms throughout the picture is related to the spirit and subject matter of the whole work, which is agitation and lack of resolution. Love, pleasure, jealousy and deceit are all entangled together in a formally and intellectually complicated pattern.

The artist has painted the figures with cold, hard outlines and

smoothly rounded surfaces. They look almost as if they were made of marble. The sense of hardness and coldness is intensified by the colours that are used: almost exclusively pale blues and snowy whites, with touches of green and darker blue. (The only warm colour is the red of the cushion on which Cupid kneels.) All this coldness and hardness is the opposite of what we normally associate with the sensuous activity that is at the centre of the picture. By such means a gesture of love or passion, usually tender or burning, is here rendered as calculating and frigid.

A kind of tension is set up between the form and colours on the one hand and the subject matter on the other – a tension altogether in keeping with the paradoxical, perhaps slightly ironic idea behind the allegory that is represented.

Formal analysis of the design of a picture often helps us to understand its meaning better and to grasp some of the devices an artist uses to achieve the effects he is seeking.

In the twelve sections that follow we will look at pictures from many different periods and places. Although at first we shall be looking at them primarily in terms of subject matter, later we shall concentrate increasingly on aspects of form and composition that are not easily appreciated at first glance. Along the way we shall encounter concepts – sometimes rather unexpected ones – which cannot be categorised wholly as either 'content' or 'form', but which can nevertheless be vital for the understanding and enjoyment of a picture.

We shall not consider the relationship of pictures to the society that produced them, nor shall we study pictures in chronological order. Many excellent and fascinating books on the history of art place works within their historical contexts and trace the evolution of styles from one period to the next.

But, most important, we shall not just be looking at pictures but also talking about them, for odd as it might seem, looking on its own is frequently not enough. Finding words to describe and analyse pictures often provides the only way to help us progress from passive looking to active, perceptive seeing.

2 Landscape and seascape

Landscape can be as attractive a subject to a painter as it is to any nature-lover. Some artists have actually become landscape specialists, while others have turned to this sort of study of nature only occasionally – to refresh their minds and eyes.

Contrasting the works of man with the creations of nature can produce pictures that are not only visually satisfying, but also quietly revealing of man's place in nature. Such, for example, is Constable's painting of Salisbury Cathedral (Fig.8, p. 16).

5 Claude Monet (French, 1840–1926): *Impression: Sunrise*, 1872. 19½ × 25½ins (49.5 × 65cm). Musée Marmottan, Paris

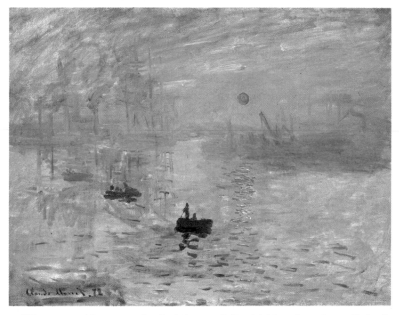

The magnificent cathedral is partially hidden by the tall leafy trees in the foreground. Cattle browse peacefully, some only dimly seen in the shadows, others picked out by the sunlight that illuminates the cathedral in its full splendour. The soaring vertical spire and the long horizontal of the roof give the main lines of the building, but the variety of detail – tall narrow windows, some of them grouped within an arch topped by a rosette window, numerous

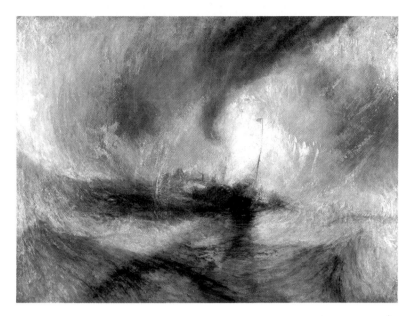

6 *Right* J. M. W. Turner (British, 1775–1851): *Steamer in a Snowstorm*, 1842. 36 × 48ins (91 × 122cm). Tate Gallery, London

7 *Below* Katsushika Hokusai (Japanese, 1760–1849): *The Great Wave off Kanagawa* (from the *36 Views of Fuji*), 1823–9. Woodblock print, 10 × 15ins (25 × 38cm). Metropolitan Museum of Art, New York (Bequest of Mrs H. O. Havemeyer, 1929)

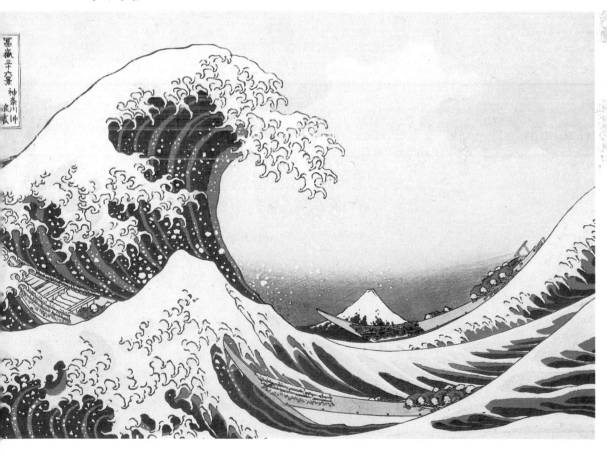

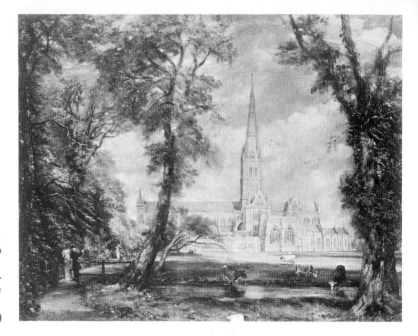

8 John Constable
(British, 1776–1837):
*Salisbury Cathedral from
the Bishop's Garden*, 1820
and later. $34\frac{1}{2}\times44$ins
(88×112cm). Metropoli-
tan Museum of Art, New
York (Bequest of Mary
Stillman Harkness, 1950)

spires, and several walls of different heights all contribute to our
perception of the cathedral as a whole. What a contrast there is
between the regular, though varied, elements of the building and
the grand, free, undisciplined variety of the natural surroundings.
Within this context, man seems very small – even the Bishop him-
self, who commissioned the painting and who appears, accompanied
by his wife, in the lower left corner.

The Dutch artist Van Gogh, who worked in France during the
last years of his life, painted the church at Auvers (Fig.9) some 70
years later in 1890. He produced a picture of very different character
from Constable's serene vision (Fig.8).

The church itself seems as full of life and activity as the grassy
banks in front of it. The vitality of the brush-strokes – so many of
them large, strong and independent, forming patterns and textures
all on their own – enlivens the sky and the path as well as the church
and its immediate surroundings.

The expectations aroused by Constable's painting are not dis-
appointed by a visit to Salisbury, but the church at Auvers does not
present one with anything like the visual excitement of Van Gogh's
picture. The building itself, like other churches, is massive, stable
and regular in form. Van Gogh's personal vision has transformed it
into a part of the landscape of the mind.

Dali's eerie landscape (Fig.10), painted in our own century, is
distinctly improbable taken as a whole. Yet it is composed of ele-
ments which, though distorted, have an uncanny air of reality about

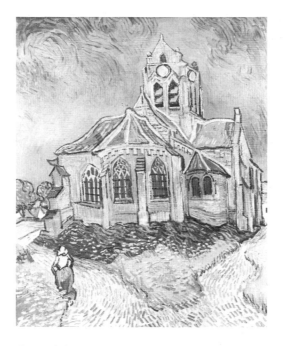

them. A landscape of cliffs, sea and flat endless plain is unexpectedly punctuated by man-made forms of harshly regular shape, for example the flat shiny-topped slab near the sea and the huge coffin-like box in the foreground, from which, perplexingly, a dead tree seems to have grown. Each of the three unpleasantly 'soft' watches takes on a different meaning from its context; one hangs like a carcass from the branch of a tree, another suggests the saddle of a

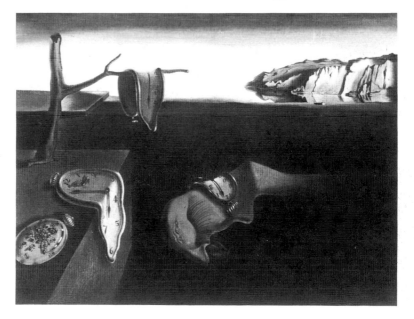

9 *Above right* Vincent van Gogh (Dutch, 1853–90): *The Church at Auvers*, 1890. 37 × 29ins (94 × 74cm). Louvre, Paris

10 *Right* Salvador Dali (Spanish, b.1904): *The Persistence of Memory*, 1931. $9\frac{1}{2}$ × 13ins (24 × 33cm). Museum of Modern Art, New York

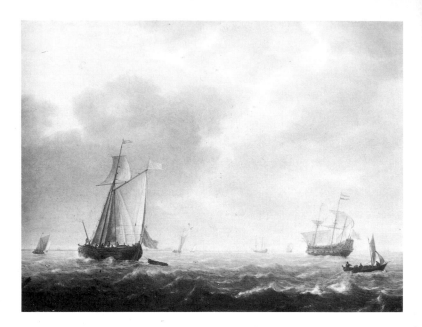

11 Simon Vlieger
(Dutch, c.1600?–53):
*A Dutch Man-of-War
and Various Vessels in a
Breeze*, c.1640. Wood,
16¼ × 21½ins (41 ×
54.5cm). National
Gallery, London

long-dead horse decomposing in an immeasurable deserted expanse
of time and space, while the third seems to have been melted in some
searing heat, and now cleaves irregularly to the rectangular box on
which it rests, a lone fly alighting on its surface.

The only solid and intact timepiece is the ovoid red watch in its
case. It seems at first glance to be decorated with a delicate black
pattern, but on closer examination this watch turns out to be the
point of attraction for a group of devouring ants which, with the
nearby fly, constitute the only living creatures depicted in the
painting.

Suggestions of permanence and decay, together with meticulous
realistic representation of the impossibly unreal, add up to a plaus-
ible, disturbing, nightmarish whole. Dali, the master of this so-called
'Surrealist' style, is able to create haunting landscapes very different
from any we might hope to visit.

In the seventeenth century, the Dutch were among the world's
greatest sailors; pictures showing ships and the sea were therefore
especially popular with them. Simon Vlieger, even when painting a
rather simple scene (Fig.11), is still able to suggest the vastness of
the sea with all its threatening turbulence and the bold beauty of the
ships that sail upon it. An immense sky forms the background for
the proud vessels, which with sails hoisted and pennants flying
catch the wind as they set off daringly for distant adventures.

By contrast, the French painter Monet was charmed by the
sparkle of water, mist rising slowly early in the morning, and little

boats bobbing unheroically on the twinkling surface of the sea (Fig.5, p. 14). He gives an intimate, homely view of the sea, which he knew well, having spent his childhood at Le Havre. He was particularly intrigued by the play of light on water and worked hard to develop a technique that could capture this effect in painting. Most of us will agree that he has succeeded admirably in conveying the blurred appearance of dawn breaking over the sea in this painting, which he called *Impression: Sunrise*. At the time the picture was exhibited in 1874, however, it was criticised for the indistinctness of the elements represented in it. Critics made fun of this painting and the others shown with it, dubbing the whole movement to which Monet belonged 'Impressionism', having singled out this work and its title as particularly ridiculous.

Perhaps this is all the more surprising because earlier in the nineteenth century Turner had made many brilliant studies of storms at sea in which all definition of form was lost in the churning waves and whirling clouds. *Steamer in a Snowstorm* (Fig.6), which he painted in 1842, illustrates how effectively Turner could show images of both sea and ship virtually dissolved by surging masses of colour.

So powerful are Turner's mighty pictures and so apt the means by which he depicts great storms and huge waves that one is tempted to think that his way is the only way to convey the chaos of a tempest.

But this is not the case. By using just the *opposite* means, firm outlines and precisely defined forms, the Japanese artist Hokusai has been breathtakingly successful in conveying the terrifying magnificence of a great wave (Fig.7). This woodcut was part of a series of views of Mount Fuji, and the conical, snow-capped volcanic peak can be seen slightly to the right of the centre of the picture. But it is, of course, the huge wave towering up at the left and curling over to break that first seizes one's attention. The swirling foam breaks into myriad little claws, each clearly defined. The great swell of the sea is revealed by sharp white spiky patterns. The whole composition is such a vivid image of the stormy sea and at the same time such a wonderfully pleasing decorative design that it is a long while before one searches out all the details and discovers the foundering ships and the straining men.

Finally, a seascape with a difference: an eighteenth-century view of Venice (Fig.12), that remarkable city built right on the sea.

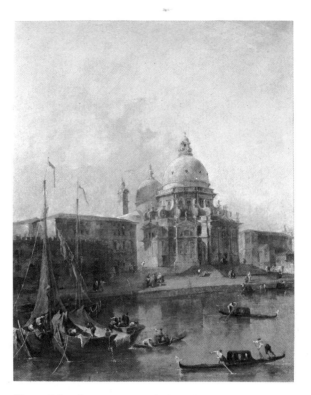

12 Francesco Guardi (Italian, 1712–93): *Santa Maria della Salute*, c.1765. 19 × 15ins (48 × 38cm). National Gallery of Scotland, Edinburgh

Guardi has here captured the glint of light on water just as success-fully as Monet (Fig.5) but in a very different way – because he has chosen to depict the moment when the sun has fully risen and floods the scene with dazzling light.

The main subject of the painting is the great church of Santa Maria della Salute, which dominates the scene as majestically as does Constable's Salisbury Cathedral (Fig.8). It is massive and solid, and yet so cleverly has Guardi stretched above it a vast, lustrous sky and so skilfully has he buoyed up the building with radiant, pale colours that it seems at one and the same time to be securely anchored and to float serenely between sea and air.

Again, as in Constable's painting, the church building dwarfs the human beings in front of it – only this time the human beings are not a staid English couple but animated Italians, restlessly crossing the lagoon or gesticulating along the waterfront, probably in pursuit of their mercantile aims in what was a frenetic commercial city. Though Guardi's picture was not intended to be anything more than a view of a particularly lovely part of Venice, it nevertheless presents a piquant contrast between the vision of beatific stability offered by the church and the scurrying anxiety of the people for whom it was built.

3 Portraits

For many centuries artists made a living by painting portraits, and some still do so today. Portraits are popular for two reasons: those portrayed enjoy having their features recorded for posterity, and those who look at pictures like finding out what people in the past looked like.

Portraits need not only be of individuals; they can also be of groups. For instance, during the sixteenth and seventeenth centuries, Dutch people who acted together in one way or another, for example as governors of charitable institutions, town councillors, or even members of the Guild of Surgeons, commissioned group portraits. The earliest group portraits represented companies of the Civic Guard; Fig.13, painted by Cornelis Anthonisz. in 1533, is a typical example. Each member of the Civic Guard contributed something towards the payment of the artist and each expected in return that he would be portrayed clearly and faithfully. The painter's careful delineation of each individual and his even-handed treatment of all the members of the group accorded well with the terms of the contract, but the result is not a very exciting painting. In fact it is little more inspiring than the usual school 'class photograph' in which everybody is lined up, facing front on two or three levels, the solemn array of individual faces becoming a little anonymous just because there are so many.

Group portraits continued to be painted well into the seventeenth century in Holland, but by then artists had become increasingly keen to produce pictures that were interesting in themselves as well as satisfying to their clients. Thus when Frans Hals portrayed the *Banquet of the Officers of St George* in 1616 (Fig.14), he tried to create a painting that was more vivid and exciting to look at. Instead of setting all the figures statically around the table, he united them in response to a central event: the parading of the banner. (The groups of Dutch officers who chose to have themselves shown so convivially gathered for a dinner had serious military functions to perform at other times.) The banner itself adds a splash of colour

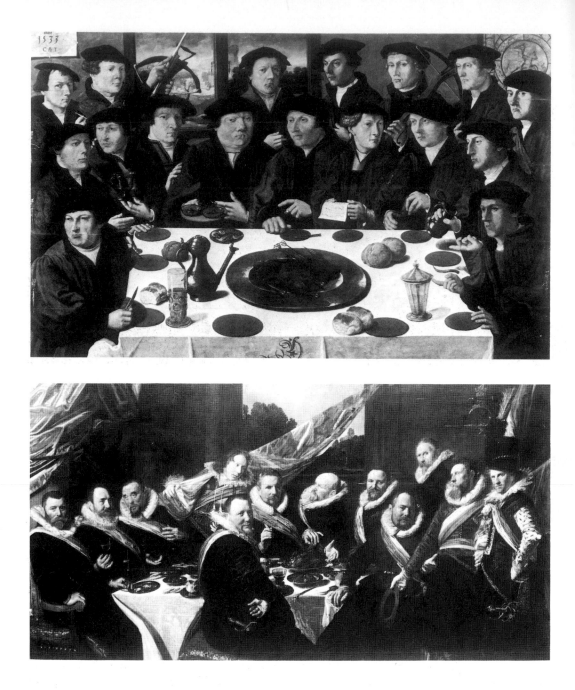

13 *Top* Cornelis
Anthonisz. (Dutch,
1499–c.1555): *Banquet
of the Civil Guard*, 1533.
51 × 81¼ins (130 ×
206cm). Historical
Museum, Amsterdam

and a vigorous diagonal accent to the already lively composition.
Though Hals has succeeded in producing a much more interesting
work of art than Anthonisz., he has still conscientiously fulfilled the
requirements of the commission he was given and has portrayed
each member of the company with great fidelity. No one is particu-
larly flattered or made especially prominent, but each is rendered as

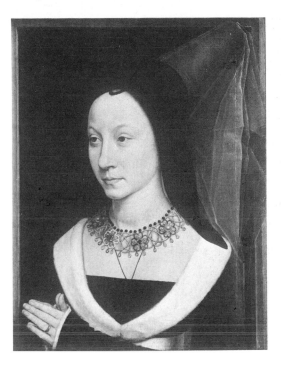

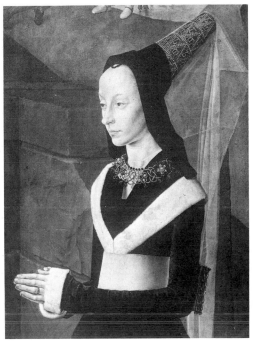

14 *Below left* Frans Hals (Dutch, 1580–1666). *Banquet of the Officers of St George*, 1616. 69 × 127½ins (175 × 324cm). Frans Halsmuseum, Haarlem

15 *Above* Hans Memling (Flemish, active c.1465–d.1494): *Portrait of Maria Portinari*, 1472. Tempera, 17½ × 13½ins (44.5 × 34cm). Metropolitan Museum of Art, New York (Bequest of Benjamin Altman, 1913)

16 *Above right* Hugo van der Goes (Flemish, active 1467–d.1482): *Maria Portinari*, detail from the Portinari Altarpiece (*Adoration of the Shepherds*), c.1475. Uffizi, Florence (see also Fig.52)

a unique individual. This is what we usually expect from a portrait – namely, that it should show exactly what a person looked like.

These expectations, however, may be a little naive. Let us look, for example, at two portraits of the *same* person, Maria Portinari (Figs.15 and 16). Both were done by careful, highly competent artists, both record roughly the same features, but the two are so different in character that it is not at all easy to decide what the real Maria Portinari looked like.

The earlier portrait (Fig.15) was painted by Memling in 1472, the later one by Hugo van der Goes around 1475 (Fig.16). Hugo's portrait is part of an altarpiece the centre of which showed the infant Jesus adored by shepherds (Fig.52, p. 60). The donors, who had commissioned the painting, appeared on the wings: Tommaso Portinari and his sons on the left and his wife Maria and her daughter to the right. These contemporary figures wished to be commemorated by being represented, diminutive but devout, participating in the worship of the Holy Family. The large figures of their patron saints behind them act, as it were, as sponsors.

But let us look more closely at Maria Portinari as she has been portrayed by Hugo van der Goes (Fig.16). He has apparently spared no pains in the careful detail, an infinite number of minute brush-strokes combining to delineate her hollow cheeks, her long nose and intense expression.

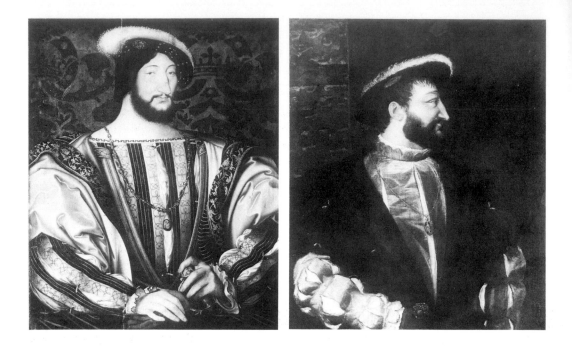

By contrast, in Memling's portrait (Fig.15) she appears super-
ficial, almost shallow, entirely lacking in the depth of feeling and
intensity revealed in Hugo's portrait. Her features are distinctly
prettier, without the angularity and character of Hugo's portrait.
Memling has worked just as hard as Hugo; the execution of his
painting is just as fine and careful. We are left wondering whether
Memling has flattered his sitter or Hugo has imparted some of his
own profundity to her more superficial character. Does either
portrait show us what Maria Portinari *really* looked like?

What a person actually looks like is one thing; how he or she would
like to appear is another. To figures in public life, the second is often
of much greater importance than the first. We know how hard
politicians nowadays work on their 'images'. Royal personages in
the past were no less sensitive on this point. For royal portraits,
physical resemblance is only part of what is required: the image of
a king must look every inch a king.

Has the French painter Clouet succeeded in conveying this in his
portrait of François I of France (Fig. 17)? The king is very richly
dressed, and his presence dominates the picture. But when you
compare this portrait with the great Titian's portrait of the same
king (Fig.18), what a world of difference there is! The bold turn of
the king's head, his majestic bearing, even the authoritative set of
his shoulders in Titian's portrait give him a heroic quality that was
much prized by regal patrons. Though Titian had not seen his royal

sitter face to face (he based his portrait on a medal depicting the king in profile), his bold conception and his vigorous brushwork make Clouet's meticulous execution look almost mincing. Little wonder that kings and emperors wished to be painted by Titian; and it is no surprise that later artists (such as Rubens and Van Dyck) who were similarly able to give their royal sitters an air of unstrained grandeur became much sought after as court painters.

Sometimes the most important demand from a portrait is that it should convey a sense of the *character* of the person represented. In such instances neither the actual physical appearance of the person nor the way he would wish to appear matter very much. We can see examples of this every day in the political cartoons printed in newspapers – although these often lean towards caricature rather than characterisation. Artists are concerned with characterisation in a

19 *St Mark*, detail from the Ebbo Gospels, c.816–835. 10 × 8ins (25.5 × 20cm). Bibliothèque Municipal, Epernay

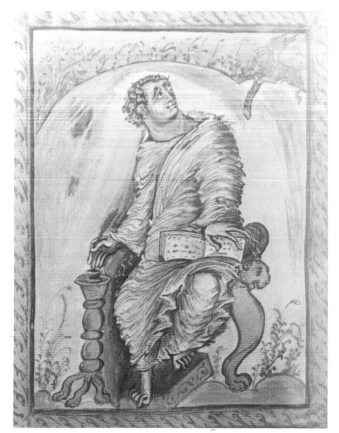

more profound sense. We see this most clearly when painters are asked to make portraits of people they have never seen. For example, there was an old tradition going back to classical antiquity that the text of a book should be preceded by a portrait of its author. When the book was one of the gospels – which was frequently the case in the Middle Ages – the artist was faced with a problem: nobody knew what any of the evangelists (the authors of the gospels) really looked like. He could base his portrait on earlier (also imaginary) representations or he could try to imagine for himself what sort of character an evangelist would have and how he would appear when he was inspired to write down the word of God. Fig. 19 shows how a ninth-century artist portrayed the evangelist St Mark composing his gospel. The saint is seated behind his inkwell, his book open on his lap. His brows are furrowed as he looks anxiously up towards heaven, where his symbol (the winged lion) hovers, encouragingly holding a scroll.

Surprisingly enough, imaginary portraits can be among the most moving in painting. Such, for example, is Rembrandt's portrait of *Aristotle with the Bust of Homer* (Fig.20). Aristotle was the renowned Greek philosopher of the fourth century BC who acted, for a while, as the tutor of Alexander the Great, king of Macedonia. Sculptured portraits of Aristotle were made in antiquity, but Rembrandt did not base the features of his philosopher on them; this richly complex character with his sorrowful expression is derived from some nearer and closer experience. Aristotle is not clad like an ancient philosopher but like a contemporary courtier. He fingers the gold chain that he wears as a mark of royal favour – an allusion to his relationship to Alexander – but he gazes thoughtfully into the distance as he places his right hand on the bust of Homer, the great blind poet whose work so profoundly influenced Greek culture and whose hero (Achilles) was a model for Alexander himself. The marble bust of Homer in the painting *is* copied from an antique portrait – though it is also an imaginary one, made some six centuries after Homer's death. No one knew what the inspired bard had actually looked like, but the (unknown) sculptor who created this image had clearly felt the power of his poetry and somehow succeeded in producing one of the most memorable portraits we have from antiquity – despite the fact that it can bear no physical resemblance to the man it purports to portray.

Sometimes a portrait may be primarily a work of art and only

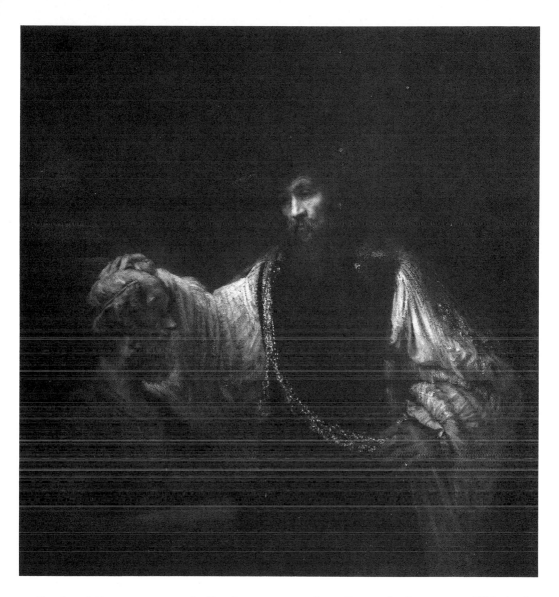

20 Rembrandt Harmensz. van Rijn (Dutch, 1606–69): *Aristotle with the Bust of Homer*, 1653. 56½ × 53¾ins (143.5 × 136.5cm). Metropolitan Museum of Art, New York (purchased 1961)

secondarily the representation of a particular person. This is the case with Picasso's portrait (Fig.21) of the art-dealer Vollard. At the time Picasso painted this portrait in 1910 he was deeply immersed in the formulation of the style called 'Cubism'. He and some of his friends took Cézanne's suggestion (see p. 38) that an artist should seek to reveal the cones, spheres and other geometrical forms that underlie natural appearances to its logical conclusion, and maybe even beyond. Thus you see that not only the face and figure of Vollard are broken up into sharply-angled faceted shapes, but even the space behind and around him has been treated in the same way. The age-old distinction between the figure and the background has

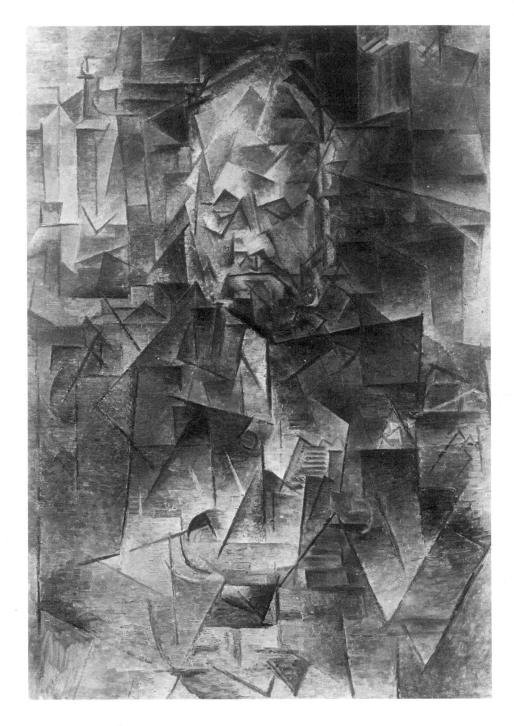

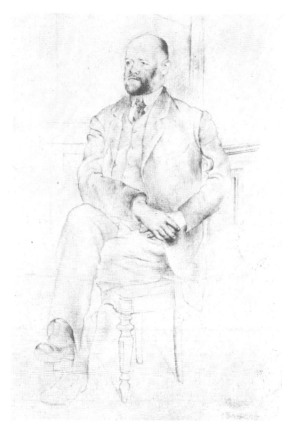

21 *Left* Pablo Picasso
(Spanish, 1881–1973):
*Cubist Portrait of
Ambroise Vollard*, 1910.
36 × 25½ins (91 × 65cm).
Pushkin Museum,
Moscow

22 *Right* Pablo Picasso:
Ambroise Vollard, draw-
ing, 1915 18½ × 12½ins
(46.5 × 32cm). Metropo-
litan Museum of Art,
New York

been abolished and the entire surface of the canvas is treated as a
homogeneous whole. This gives the picture the sort of unity that is
seldom found in representational works, but is more usual in purely
abstract ones (like Fig.4). In Picasso's painting nevertheless there is,
surprisingly, a strong – though indefinite – suggestion of depth,
space, and even volume. What is perhaps most surprising of all is
the compelling way in which the features and personality of Vollard
emerge from the welter of jagged, broken shapes. Five years later
Picasso made another portrait of Vollard (Fig.22); it is a fine
drawing in a conventional style. Figure and ground are clearly
distinguished from one another. The man, his seat, his clothes, his
environment – all are unambiguously represented, and yet one
wonders if his personality is any more vividly conveyed than in the
earlier Cubist portrait (Fig.21).

4 Everyday life and everyday things: Genre and still life

Humble scenes of everyday life were in some periods considered rather undignified, and although they might be sketched in the borders of manuscripts during the Middle Ages or drawn on pieces of pottery in classical Greece, they did not provide the subjects for serious pictures. In other periods, however, both patrons and artists delighted in looking at and depicting life around them. Dutch art collectors of the seventeenth century, for instance, particularly enjoyed genre painting (as it is called). The numerous pictures that were produced to satisfy this market were often, despite their unremarkable subjects, both beautiful and fascinating.

Dutch painters show us bar-room brawls, boisterous family parties, elegant entertainments, merry skaters cavorting on the ice,

23 Jan Steen (Dutch, 1626–79): *The Dissolute Household*, c.1665. 30½ × 34½ins (77 × 87.5cm). Wellington Museum, Apsley House, London

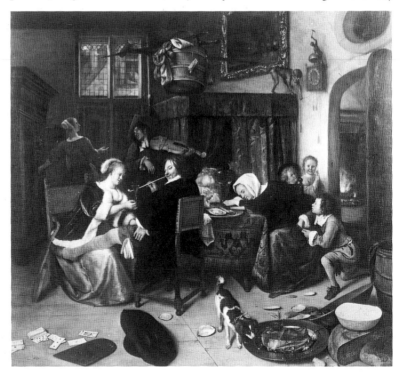

ordinary women attending to their daily chores with quiet dignity – all the rich variety of contemporary life.

Jan Steen's *The Dissolute Household* (Fig.23) provides a good example. The clock by the door in the picture shows that it is five minutes to five, and a late afternoon light seeps in through the mullioned window high up to the left. The master of the house has clearly dined well and is enjoying an after-dinner clay pipe. A richly dressed buxom lady – who may or may not be his wife – is offering him a glass of wine. He looks out at the spectator with his hand on his hip and a gleam in his eye. The housekeeper, seated at the other end of the table, has fallen into a deep slumber, oblivious to the fact that the kneeling boy beside her is helping himself to the contents of her purse.

Cards lie scattered on the floor along with huge oyster shells, a neglected slate and the master's casually discarded hat. To the right there is an abundance of bread and cheeses, and a savoury joint of meat which is of interest to the dog. The more one looks, the more amusing detail one finds – the inquisitive neighbour peering out of his window at the servant girl flirting with the musician behind the master's back; the two children at the right, one of whom provocatively holds up a coin, and finally the monkey perched on the bed canopy playing with the weights of the clock. Perhaps it isn't five to five after all! What does time matter in such a household?

But Steen was not only concerned with creating an interesting picture. He also wished to convey a moral message: the disgraceful behaviour of their elders is obviously setting a bad example for the children and even has an adverse effect on the servants; the dog, similarly, is about to succumb to his animal appetites; and the monkey is literally 'wasting time'.

In this painting Steen casts a wry look at the activities of the well-to-do. At other times his subjects were the common people, whose antics he could observe closely in the tavern that he owned.

A painting made just a century earlier, in 1565, provides a view of the outdoor life and labour of common folk (Fig.24). Breughel has here captured the essence of the harvest: the gruelling hard work of the people plodding along the path out through the field, the men hacking away with their scythes to the left and, to the right, a woman bent over to tie up a bundle of hay; the simple pleasures of eating and drinking shown in the group seated in the foreground;

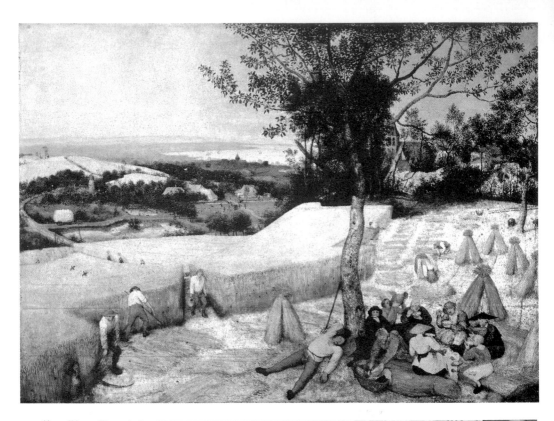

24 *Above* Pieter Breughel the Elder (Flemish, 1525/30–69): *The Harvest* (*August*, from the *Months* series), 1565. $46\frac{1}{2} \times 63\frac{1}{4}$ ins (118 × 160.5cm). Metropolitan Museum of Art, New York (Rogers Fund, 1919)

25 *Right* L. S. Lowry (British, 1887–1976): *Coming from the Mill*, 1930. $16\frac{1}{2} \times 20\frac{1}{2}$ ins (42 × 52cm). City of Salford Art Gallery, Lancs

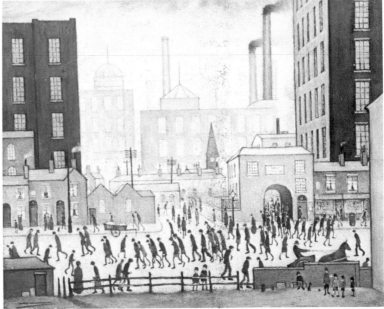

and, most moving of all, the exhausted peasant stretched out at the foot of a tree enjoying the blessing of sleep.

In the past most work was agricultural; now more of it is industrial. Urban life and factory labour seem unpromising subjects for pictures, but Lowry, undeterred by such considerations, came vigorously to grips with his own environment. Even in showing cold, tired people trudging home through the treeless spaces between tall buildings (Fig.25), he was able to reveal the beauty of pattern that can be elicited from the bleakest surroundings.

The plight of the urban poor – ill-clothed, hungry and long-suffering – is rendered with the utmost compassion by Daumier in his painting, made in the 1860s, of *The Third-Class Carriage* (Fig.29, p. 36). It was a theme to which Daumier returned several times. The dark, gloomy colours and the harsh irregular outlines forcefully convey the sombre mood and the patient endurance of the weary family huddled together on the hard wooden seats. There is little meticulous detail in the painting. Strong, black lines suffice to suggest the circumstances and create the atmosphere.

By contrast, the Limbourg brothers' illustration for the month of February (Fig.30) in a lavishly decorated Book of Hours painted for an aristocratic patron in the early fifteenth century is gaily coloured and full of the most exquisite detail. Here peasants are shown shivering in the cold of winter. Three within the wooden shack – the front wall has been omitted by the painter so that we can see inside – crowd around the hearth, indecorously pulling their clothes away from their chilled bodies so that they can best profit from the fire. A woman blows on her cold hands as she approaches from the right; a man chops wood energetically, while another drives a donkey through the snowy wastes to the distant town. The birds peck hungrily for the meagre crumbs on the ground and the sheep huddle together in the fold. The life of the common people has been drawn with great elegance for the courtly patron who demanded that everything he owned should be touched by beauty and who might not have enjoyed the sight of more realistically portrayed peasants in shabby clothes and impoverished dwellings.

Life is not all work and suffering; people also relax and play. Some painters prefer to show these happier moments, and none has done so more joyously than Renoir. For instance, his 1881 painting *Luncheon of the Boating Party* (Fig.26) is the simplest of subjects,

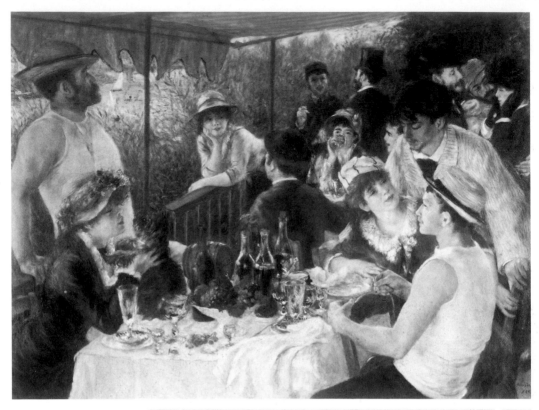

26 *Above* Pierre-Auguste
Renoir (French, 1841–
1919): *Luncheon of the
Boating Party*, 1881.
51 × 68ins (130 × 173cm).
Phillips Collection,
Washington DC

27 *Right* Rembrandt:
Learning to Walk,
probably 1630s. Red
chalk drawing, $10\frac{1}{2} \times$
13ins (26.5 × 32.7cm).
British Museum, London

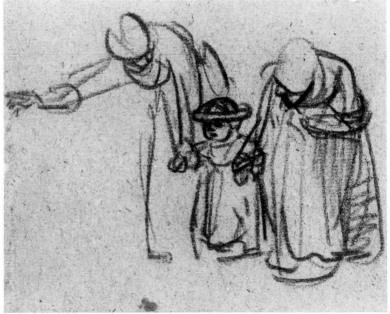

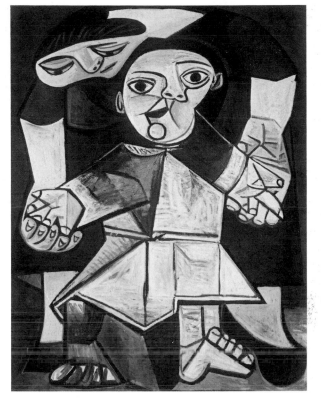

28 Pablo Picasso: *The First Steps*, 1943. 51¼ × 38¼ins (130 × 97cm). Yale University Art Gallery, New Haven, Conn. (Gift of Stephen C. Clark)

but pure delight. It is a warm summer day – men have stripped to their undershirts – the table is laden with wine bottles and glasses, pretty girls are wearing their new hats. Everybody is in a good mood, chatting, drinking, crooning to a puppy, or just enjoying the deliciousness of a warm sunny holiday outing. The colours are bright, soft, and radiant. The brushwork is light and free. Everything combines to convey an easy pleasure in the simple joys of life, so happily shared here by both the painter and his subjects – for the members of the boating party were Renoir's friends and the charming young woman so coquettishly playing with the dog was to become his wife.

A drawing by Rembrandt (Fig.27) strikes a quieter note. A little child is about to take his first steps. His mother, strong and mature, bends over to hold his hand. She turns to him gently and extends her other arm encouragingly, pointing the way they are to go. To the right of the drawing we see the old grandmother. She is bent with age, but she too holds one of the child's hands, though the support she can offer is very limited; she turns her sharp-featured old head to look at her grandchild with infinite tenderness. The baby is setting out on a great adventure – timidly. With the deftest of strokes Rembrandt has managed to convey the anxious ex-

35

29 *Below* Honoré Daumier (French, 1808–79): *Third-Class Carriage*, 1863–5? 25¾ × 35½ins (65 × 90cm). Metropolitan Museum of Art, New York.

30 *Opposite* Limbourg Brothers (Flemish, d.c.1416): *February*, from the *Très Riches Heures du Duc de Berry*, 1413–16. Full page 11 × 8¼ins (28 × 21cm). Musée Condé, Chantilly

pression on the child's face. The drawing is remarkable for the economy of means used to show so unmistakably three different stages of life, three different attitudes and the subtle web of tender feelings that binds human beings to one another.

A child's first step is also the subject of one of Picasso's paintings (Fig.28, p. 35). It has none of the delicate realism of Rembrandt's drawing, but it is just as full of human feeling. Rembrandt hinted at the child's anxiety; Picasso makes it explicit. One large foot, all the toes tense, is extended forward; the child's face is distorted with the anguish of uncertainty – where will that foot land? She stretches out her little hands to either side, fingers wide, arms stiff. Behind her, looming quietly, encircling her, is her mother. Inconspicuously

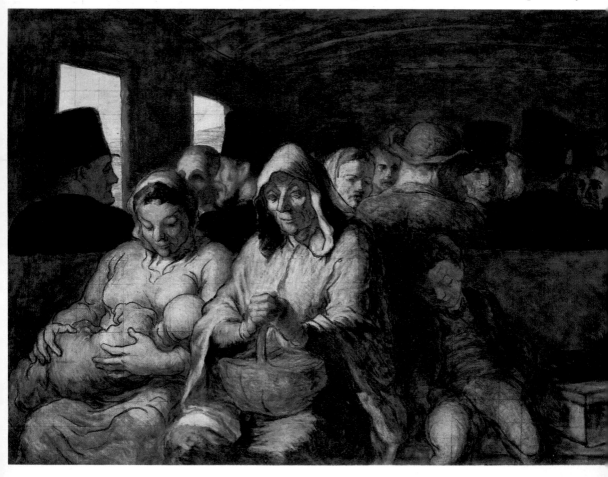

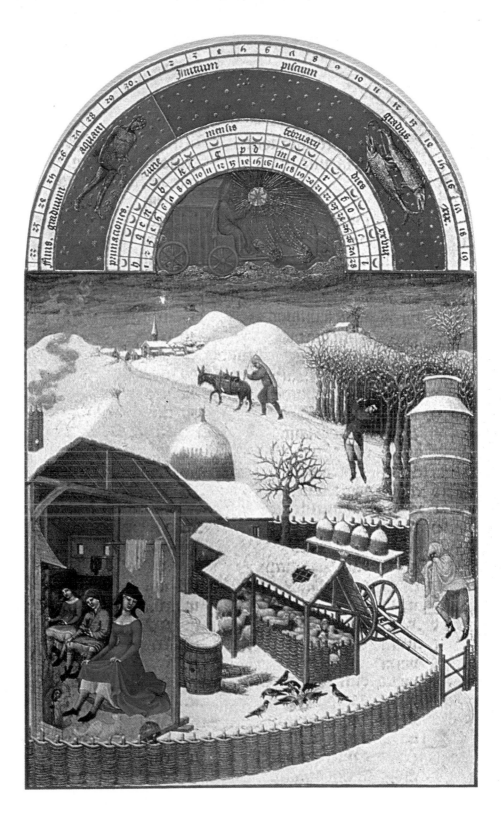

37

maternal hands support the little girl's; the mother's gentle face shows that she has sympathy with her child's anxiety, but that she also has confidence in her.

It is an extraordinary image that suggests how the mother makes herself into a protective cocoon enveloping her child and how the child, though totally absorbed in her own feelings, accepts the helping hands as a matter of course. The distortions of reality have enabled the artist to penetrate beneath the surface appearance of events and emotions.

Finally, two pictures of men playing a game at a table (Figs.31 and 32). At first glance they look so similar that it is hard to believe nearly two thousand years separate them. The earlier one (Fig.31) was found on the wall of a tavern in Pompeii. It is a quick sketch of little artistic merit, but lively and appropriate to its setting. It was one of a series of paintings decorating an inn which showed the activities of the customers – gaming, quarrelling and finally being chucked out. Such paintings combined advertising with decoration, injunctions to enjoyment tempered by subtle reminders that rowdy behaviour ought not to get out of hand.

But Cézanne's *Card Players* (Fig.32), however superficially similar, is actually a very serious work of art. Cézanne may have taken his inspiration from a painting by a seventeenth-century French artist (Le Nain); he re-worked the theme several times, finally reducing the number of figures to the two we see here. The subject itself is rather trivial, but Cézanne, through his careful analysis of form and his subtle balance of the various elements, has invested it with grandeur and dignity. The two men seated opposite each other provide strong vertical accents on either side of the canvas. The nearer arm of each looks as if it is basically composed of two cylinders. The four cylinders taken together describe the shape of a shallow 'W', the gently angled lines linking the two upright figures. Throughout the picture Cézanne emphasises the simple geometrical shapes underlying the forms of the bottle, the table, the windowsill, even the hats and knees of the players. The colours are muted and austere. The result is a sense of restfulness and order that arises from the lucid arrangement of clear, uncomplicated shapes.

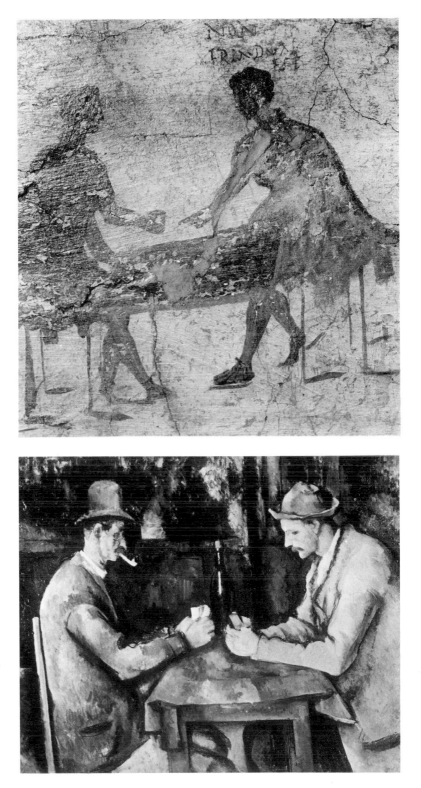

31 *Above Men Playing Dice*, inn-sign from Pompeii. 1st century AD. Museo Nazionale, Naples

32 *Right* Paul Cézanne (French, 1839–1906): *Card Players*, c.1890–5. 18¾ × 22½ins (47.5 × 57cm). Louvre, Paris

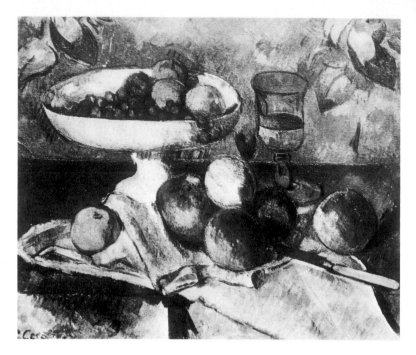

33 Paul Cézanne: *Fruit-bowl, Glass and Apples*, 1879–82. 18 × 21½ins (45.7 × 54.5cm). Private collection, Paris

STILL LIFE

Cézanne's interest in discovering the geometrical forms that underlie appearances and can give order to painted arrangements made him a superb painter of still lifes (Fig.33). A bowl of fruit, a glass, a wrinkled cloth upon a table, these simple elements presented him with a challenge in design: how to give firm visual order to an apparently casual array of objects.

Still lifes had been painted in classical antiquity, and the recovery of the art of realistic representation in the Renaissance together with an intense respect for the works of classical antiquity encouraged a revival of this type of painting. Still life paintings sometimes contain heaps of fruit piled up in luscious abundance (Fig.35), silvery fish lying on a plate, subtly coloured game birds hanging on a wall, or magnificent cascading arrangements of brilliant flowers. Still lifes may also consist of shiny pewter vessels, glinting transparent glasses, richly woven rugs spread on a table, books, jars, pipes, a writer's inkwell or the painter's brush and palette. All manner of inanimate objects are suitable subjects for still lifes, for the painter's skill suddenly makes us aware of the artistic properties of ordinary things. This fact was given a startling fresh immediacy in the 1960s by Andy Warhol, who made us look into our store-cupboards with a new aesthetic sense of order after he had painted this absolutely literal picture (Fig.34) of Campbell's soup cans.

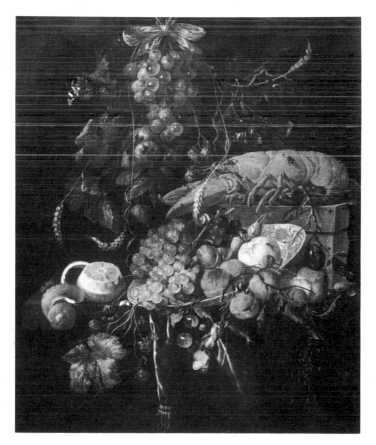

34 *Above* Andy Warhol
(American, b.1930): *100
Soup Cans*, 1962. 72 ×
92ins (183 × 234cm). Leo
Castelli Gallery, New
York

35 *Right* Jan Davidsz. de
Heem (Dutch, 1606–84):
*Still Life with Fruit and
Lobster*, late 1640s.
27½ × 23ins (70 × 59cm).
Rijksmuseum, Amster-
dam

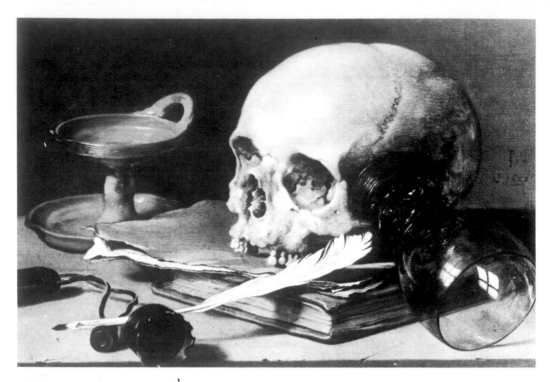

36 Pieter Claesz. (Dutch, d.1661): *Vanitas Still Life*, 1623. Wood, 9½ × 14ins (24 × 35.5cm). Metropolitan Museum of Art, New York (Rogers Fund, 1949)

Still lifes can even carry a moral message, striking a serious, almost tragic note (Fig.36). The presence of a skull amid the beautifully painted objects is an inevitable reminder of the transience of all things. It is intended to call to mind the moving words in *Ecclesiastes*: 'Vanity of vanities; all is vanity' (Ecc. 1:2).

Such 'Vanitas' still lifes were very popular just at the time when Dutch and Flemish painters were producing the most exuberantly rich assemblages of flowers, fruit, fish and birds – wonderfully rendered, vividly suggestive of material well-being and the good things in life (Fig.35). Their seriousness cast a shadow of literary allusion over all still lifes, reminding men:

'In the day of prosperity be joyful, but in the day of adversity consider: God also hath set the one over against the other, to the end that man should find nothing after him.'

Ecclesiastes 7:14

5 History and mythology

History and mythology provide grand, dignified subjects for artists.

Sometimes artists have been inspired by historical events, either in their own times or in the past, and of their own accord have made pictures recording them. More frequently, powerful actors on the stage of history have been the ones to require artists to document the events in which they played a prominent part.

The most astonishing commission of a work intended to commemorate relatively recent historical events is the gigantic piece of embroidery, over 70 metres long, known as the *Bayeux Tapestry*. It was probably made by English craftsmen for Bishop Odo of Bayeux within 20 years of the events depicted. The long narrow strip is embroidered with numerous scenes (it is not really a 'tapestry', since tapestry is woven) that provide a detailed account in pictures of the events leading up to and including William of Normandy's conquest of England in 1066.

37 *The Fleet Crossing the Channel*, from the Bayeux Tapestry, c.1073–83. Wool embroidery, ht 20ins (51cm). Musée de l'Evèché, Bayeux

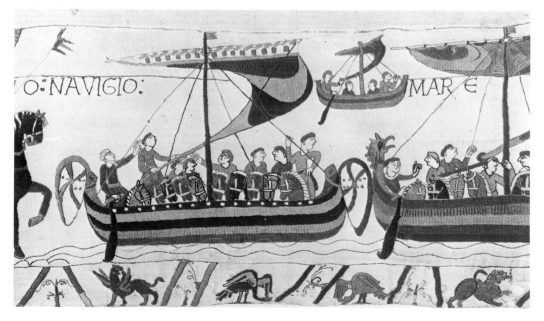

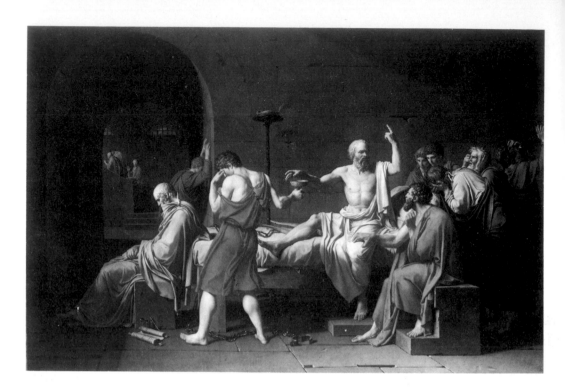

38 Jacques-Louis David (French, 1748–1825): *The Death of Socrates*, 1787. 51 × 77¼ins (129.5 × 196cm). Metropolitan Museum of Art, New York (Catharine Lorillard Wolfe Collection, 1931)

The narrative begins, probably in the year 1064, with a scene showing King Edward the Confessor giving instructions to Earl Harold, who then sets out for France. We watch Harold on his travels through England to the coast and then onto the ships that take him across the Channel. The tapestry runs along like a strip cartoon, with one event following another, embellished at the top and the bottom with a decorative border which in most parts shows birds, animals, monsters, or slain men.

Explanatory legends are stitched along the main section to help the observer understand exactly what is going on, who is participating, and where the incidents are taking place.

Harold's adventures in France are chronicled, and much fighting is shown. Then William's preparations for the invasion of England are portrayed in detail, even down to the trees being felled to build the boats that will be needed. Finally we see the battle of Hastings, in which Bishop Odo himself appears, making a most creditable, by no means solely spiritual, contribution to the ultimate victory of William.

The small excerpt in Fig.37 shows William's troops embarking and setting sail for the invasion. You can make out the words 'NAVIGIO' and 'MARE' near the top of the illustration. They are part of the inscription: *Hic Willelm Dux in magno navigio mare*

transivit et venit ad Peveneae: 'Here Duke William in a great vessel crosses the sea and arrives at Pevensey.' (William's flagship is depicted further to the right and is not visible in Fig.37.)

What a fascinating spectacle the Bayeux Tapestry makes of recent history!

History of the past could also provide inspiration for later artists, for instance Jacques-Louis David who in 1787 painted this picture (Fig.38) of the death of Socrates. Socrates, a humane and thoughtful man, had been condemned to death in Athens in 399 BC on charges of 'introducing strange gods and corrupting the youth'. He left behind him a devoted band of friends and followers, the most notable of them being the philosopher Plato. Plato composed a dialogue which describes the quiet courage with which Socrates met his end – he was obliged to drink a lethal draught of hemlock. The dialogue is called the *Phaedo* and in it Phaedo, who was in the prison with Socrates on the day he drank the poison, tells an acquaintance how Socrates spent his last hours and finally met his death. Towards the end Phaedo relates:

'Soon the jailer ... entered and stood by him, saying: – "To you, Socrates, whom I know to be the noblest and gentlest and best of all who ever came to this place, I will not impute the angry feelings of other men, who rage and swear at me when in obedience to the authorities I bid them drink the poison – indeed, I am sure you will not be angry with me; for others, as you are aware, and not I are to blame. And so fare you well, and try to bear lightly what needs be – you know my errand." Then bursting into tears he turned away ...'

A little later Socrates raised the cup to his lips and cheerfully drank off the poison. Phaedo recounts: '... hitherto most of us had been able to control our sorrow; but now when we saw him drinking, and saw too that he had finished the draught we could no longer forbear, and in spite of myself my own tears were flowing fast; so that I covered my face and wept, not for him, but at the thought of my own calamity in having to part from such a friend. Nor was I the first; for Crito, when he found himself unable to restrain his tears, had got up, and I followed; and at that moment, Apollodorus, who had been weeping all the time, broke out in a loud and passionate cry which made cowards of us all. Socrates alone retained his calmness ...'

Such is Plato's vivid and moving description of the scene. You

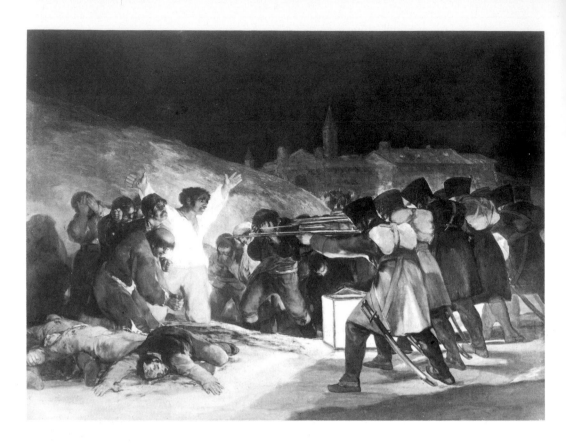

39 Francisco de Goya (Spanish, 1746–1828): *The Third of May 1808*, 1814. 105 × 136ins (266 × 345cm). Prado, Madrid

can judge for yourself how successful David has been in his efforts to convey it in paint.

The Spanish painter Goya felt very strongly about events in his own time. His commemoration of *The Third of May 1808* (Fig.39) is one of the most powerful condemnations of the brutality of war ever created. An apparently endless stream of Spanish patriots toil up the hill towards their deaths. Unarmed and dishevelled they have given all they could for their country and now have nothing left but to die for her. In the foreground those who have already been shot are sprawled messily on the ground, hideously wounded. Our attention is caught by the man in a white shirt just about to be executed. Before him there is a pool of blood. He throws up his hands in a last passionate gesture – utterly defenceless. Confronting him is the long orderly line of the faceless members of the firing squad, rifles neatly aligned, about to shoot.

No less moved by events in his time was another Spaniard: Picasso. He was commissioned by the Spanish Republican government (soon to be defeated in the civil war) to paint a picture for the Spanish Pavilion at the International Exhibition of 1937 to be held in Paris. Outraged by the barbaric saturation bombing of the ancient

Basque town of Guernica by the Fascists, he took the sufferings of its citizens as his theme (Fig.40). But rather than painting a realistic picture like Goya's, Picasso tried to capture and convey the anguish and suffering through more symbolic forms, grossly distorted to achieve the greatest possible expressiveness. At first glance the picture is chaotic – as the town itself was, when plane after plane had come zooming overhead dropping bombs and firing at the fleeing citizens (films recording the actual bombing have been preserved). Slowly one begins to distinguish intelligible shapes. Starting at the right there is a figure with screaming mouth and wildly upstretched arms (like the white-shirted man in Goya's painting, Fig.39). A woman below him races to the left; she is in such a hurry that her further leg seems to get left behind. In the centre there is a horse with a terrible gash in its side. In one of his earlier drawings for the picture, Picasso sketched a little winged horse emerging from this gash: an emblem of hope. But in the final painting he has not used the idea. Beneath the horse's feet lies a warrior, his eyes dislocated in death; one hand holds a broken sword and a flower, the other is extended helplessly – empty. At the far left a woman turns her head upward to scream out her agony; in her arms she holds her dead baby (Fig.41). Her distorted face is a mask of pain – a desperate shriek made visible. The dead baby hangs in her arms like a rag doll. It is so limp and lifeless that even its nose droops. How different this

40 Pablo Picasso: *Guernica*, 1937. $137\frac{1}{2} \times$ 306ins (350 × 780cm). Prado, Madrid

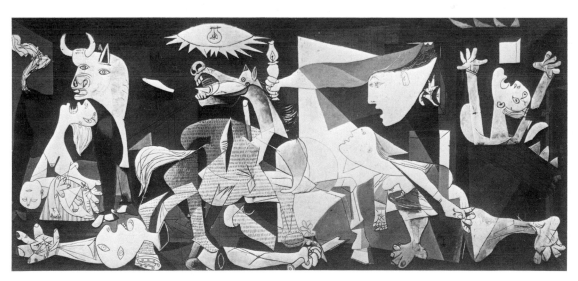

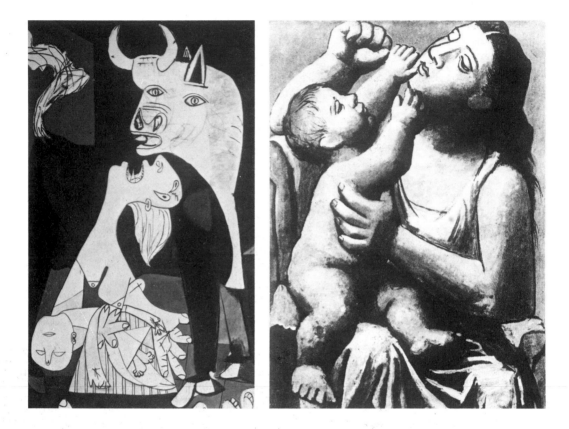

41 *Above* Detail of the mother and child from *Guernica* (Fig.40).

42 *Above right* Pablo Picasso: *Mother and Child*, 1921–2. 38 × 28ins (96.5 × 71cm). Alex L. Hillman Family Foundation, New York

searing image is in feeling from the tender scene of mother and child that Picasso created 15 years earlier (Fig.42).

Like Picasso, the seventeenth-century Flemish painter Rubens deplored the ravages of war, and like Picasso he tried to make his own anti-war statement without the use of straightforward realism. At that time, however, there could be no question of expressive distortions. They could not have been thought of by the painter, nor tolerated by the patrons. So Rubens painted an *Allegory of War* (Fig.43). He did this by making use of the traditional characters of some of the ancient Greek and Roman gods and goddesses, principally Mars, god of war, and Venus, goddess of love. To these divinities he added personifications of place, like Europe, and evils, like Pestilence and Famine. These symbolic figures are all combined in a violent, dramatic scene. Rubens himself explained the meaning in a letter:

'The principal figure is Mars, who has left the open temple of Janus (which in time of peace, according to Roman custom, remained closed) and rushes forth with shield and blood-stained sword, threatening the people with disaster. He pays little heed to Venus, his mistress, who, accompanied by her Amors and Cupids, strives with caresses and embraces to hold him. From the other side, Mars is dragged forward by the Fury Alekto, with a torch in her hand. Nearby are monsters personifying Pestilence and Famine, those inseparable partners of War. There is also a mother with her child in her arms, indicating that fecundity, procreation and charity are thwarted by War, which corrupts and destroys everything . . . That grief-stricken woman clothed in black, with torn veil, robbed of all her jewels and other ornaments, is the unfortunate Europe who, for so many years now, has suffered plunder, outrage, and misery, which are so injurious to everyone that it is unnecessary to go into detail. . . .'

43 Peter Paul Rubens (Flemish, 1577–1640): *Allegory of War*, 1638. 81 × 136ins (206 × 345 cm). Pitti Palace, Florence

Many words to explain a picture. The imagery is strange and foreign to most of us, and the visual impact, despite the vigour of movement and gesture, less immediate than that of Goya's or Picasso's pictures (Figs. 39 and 40). But the sentiments were no less deeply felt.

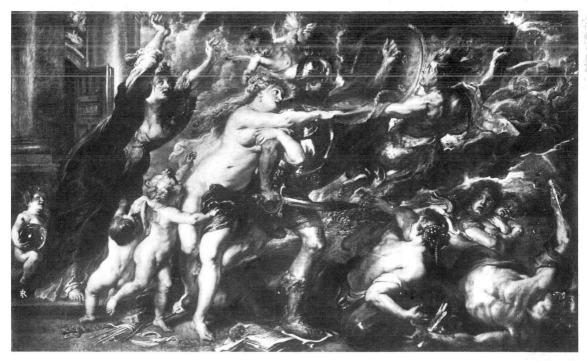

MYTHOLOGY

The world of the pagan gods and the wonderful rich cluster of stories that make up classical mythology was much appreciated by artists from the Renaissance until fairly recent times. Venus was particularly popular. Sometimes artists chose to depict her simply to have an excuse to paint a female nude; at other times they illustrated stories in which she was involved. Titian and Rubens, for instance, each in his own way chose to show Venus desperately clinging to her lover Adonis who longs to flee her embraces and join the hunt (Figs.89 and 90).

This tale is told by Ovid, whose book *The Metamorphoses* is a delectable collection of myths. In it, Ovid relates that Venus tried to beguile Adonis with the story of Hippomenes and Atalanta. Atalanta, fleetest of all mortals, was warned by an oracle that she should accept no lovers. Thus she challenged all potential suitors to a race, promising to reward the winner with her love, but doom the loser to death. Such was her beauty that many nonetheless came to compete with her, and many died. Hippomenes, unlike the others, cleverly called upon the goddess Venus for her help, so that love could triumph in the race. Venus gave him three golden apples and her blessing. Once the race began, Atalanta soon took the lead. Ovid recounts:

'Hippomenes' breath came panting from his dry lips, and the goal lay far ahead. Then, at last, he rolled forward one of the three apples from the tree. The girl stood still in astonishment, and in her eagerness to secure the gleaming fruit, ran out of her course, and picked up the golden ball. Hippomenes passed her, and the benches rang with the spectators' applause. But Atalanta, putting on a spurt, made up for her delay and for the time she had lost, and once again left the young man behind. He held her back a second time, by throwing another apple . . .' and that is the moment in the story that Guido Reni chose to illustrate (Fig.44). Hippomenes has just thrown the second apple to one side and Atalanta swerves off course to retrieve it. She already holds one apple, but cannot resist another. Hippomenes still has the third apple concealed in his left hand. In the end he uses it in the same way and wins the race, and the girl.

Not all artists seem able to capture both the spirit and the form of a classical story so aptly as Reni. The sixteenth-century German

Lucas Cranach tried his hand at one of the most famous of all pagan tales: the Judgement of Paris. Paris, the son of the king of Troy, was required to award the prize of beauty (again a golden apple) to one of three contending goddesses: Juno, Minerva and Venus (Fig.45). Cranach has tried to imagine the scene as vividly as he could, though the result looks slightly comical to us. Paris, an elegant knight of the period, is seated beneath a tree holding the prize in his hand. Mercury, the messenger of the gods, is here a bearded old fellow wearing a winged helmet. He is presenting the three lovely goddesses to Paris for his appraisal. In order to reveal their charms to the fullest, the three goddesses have taken off their clothes, but in order to remain stylish (one supposes) they have retained their jewellery, and one of them apparently could not bear to remove her fashionable hat. It all looks rather different from the unselfconscious picture of the same event painted on a Greek vase in the fifth century BC (Fig.46). In this scene Paris, who though a

44 Guido Reni (Italian, 1575–1642): *Hippomenes and Atalanta*, c.1625. 75 × 104ins (191 × 264 cm). Gallerie Nazionali di Capodimonte, Naples

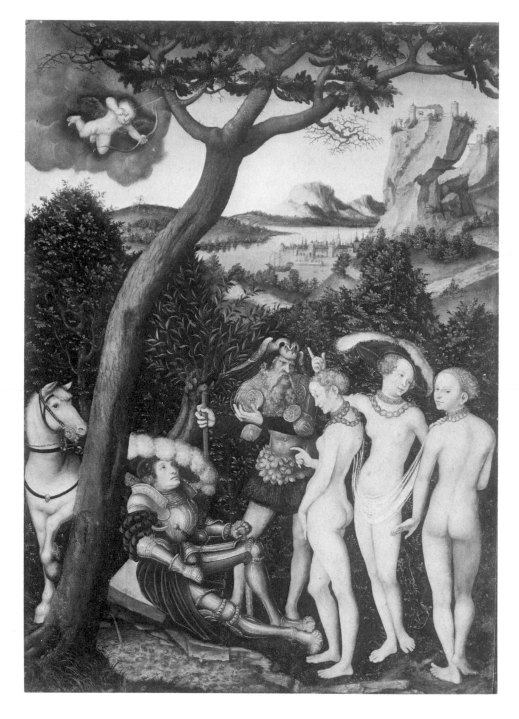

prince of Troy was temporarily acting as a shepherd, is seated to the left among his flock. He has been amusing himself by playing the lyre – for shepherding is usually a boring business. He is surprised to see Mercury (with winged boots) approaching him from the right leading the three goddesses: Minerva, identifiable by her helmet and spear; Juno, queenly wife of Jupiter, chief of the gods; and finally Venus, surrounded by fluttering little Cupids – a sure winner. There is no colour here or modelling. The orange-red figures stand out starkly against the black background, but the painter's sure, fluid lines have given this simple drawing an unforgettable elegance and grace.

An enchanting painting by Botticelli (Fig.47) shows Venus and Mars again. They are not in conflict as in Rubens' allegory (Fig.43), but most profoundly at peace. Mars sleeps, war forgotten, while little fauns (notice their horns and goat-ears) play with his lance and armour. Venus, reclining opposite him, remains wakeful and attentive. Classical authors from the time of Homer on told the tale of the illicit love of Mars and Venus, an adulterous affair in which they were eventually caught out by Venus' cuckolded husband, Vulcan. However, it is doubtful that Botticelli had this part of the story in

45 *Left* Lucas Cranach the Elder (German, 1472–1553): *The Judgement of Paris*, c.1528? Tempera on wood, 40 × 28ins (101.5 × 71cm). Metropolitan Museum of Art, New York (Rogers Fund, 1928)

46 *Below* Makron: Greek cup showing *The Judgement of Paris*, c.480 BC. Antikenmuseum, Staatliche Museen Preussischer Kulturbesitz, West Berlin

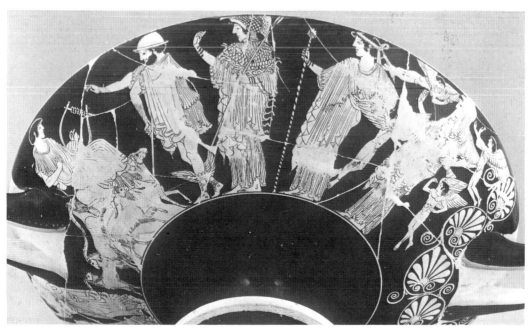

53

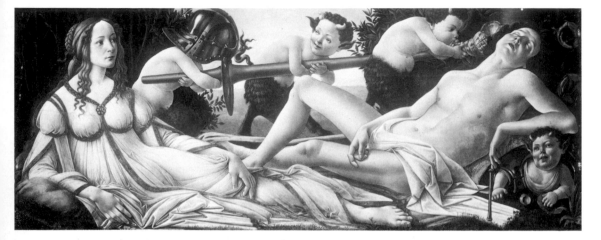

47 Sandro Botticelli
(Italian, 1444/5–1510):
Mars and Venus, mid-
1480s. Wood, 27¼ ×
68¼ins (69 × 173.5cm).
National Gallery,
London

mind, particularly as the panel seems to have been intended to decorate a marriage chest. Mars and Venus are the names of planets as well as gods, and in the astrology of the time their conjunction was supposed to be beneficial. In such a context Venus was believed to master and appease Mars and check his malignance, and that is apparently what is happening here. Botticelli is not painting a straightforward mythological illustration, any more than Rubens was (Fig.43), but making use of the same characters to create an allegory of quite the opposite sense.

·

6 Religious images

For well over a thousand years the Catholic Church was, either directly or indirectly, the most lavish of all patrons of the arts. Countless painters were given commissions for a variety of works of art which included large and impressive altarpieces, small portable altars suitable for private worship, stained-glass windows, mosaics and frescoes, and the illustration and ornamentation of bibles and books of prayers.

A wide range of subjects was considered appropriate. Most were drawn from the New Testament, particularly descriptions of the early life of Christ (Figs.52 and 53), the miracles he performed (Figs.2, 81 and 82), and the events surrounding his crucifixion and resurrection (Figs.55–58, 78–80 and 98). But devotional images for which there was no biblical text, especially pictures of the Virgin Mary (the Madonna) and Child surrounded by saints, were also popular (Figs.87 and 88), as were images of individual saints, some of whom might have a special chapel consecrated to them for which an appropriate altarpiece was necessary (Figs.48 and 74).

St Sebastian (Fig.48) was an early Christian martyr. 'Martyr' is the Greek word for 'witness' and many of the early converts to Christianity were forced to testify to their faith by sacrificing their lives. Such was the case with Sebastian. Towards the end of the third century he became the commander of a company of Praetorian guards, the special bodyguard of the Roman emperors. When his conversion to Christianity became known, the emperor, Diocletian, who doubted that one man could serve both Christ and Caesar, demanded that Sebastian either renounce his faith or face a firing squad of archers. Sebastian remained true to his religion and consequently was bound to a stake, shot with innumerable arrows, and left for dead. Miraculously, he survived. When he had recovered, Sebastian approached the emperor again to plead for toleration for Christians. This time Diocletian took no chances; he had Sebastian beaten to death with clubs.

St Sebastian is usually shown tied to a pillar (Fig.48) or a tree

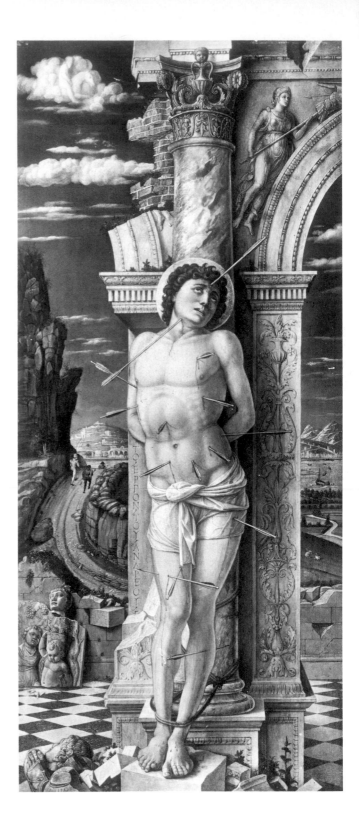

48 Andrea Mantegna
(Italian, 1431–1506):
St Sebastian, 1455–60.
27 × 12ins (68 × 30cm).
Kunsthistorisches
Museum, Vienna

(Fig.74, p. 80), pierced with arrows. (Arrows, incidentally, were associated with plague: even in pagan times the god Apollo was supposed to have sent plagues by shooting arrows, and it is hardly surprising therefore that the intercession of St Sebastian was frequently invoked as protection against the plague.) Early representations showed the saint's body pierced by so many arrows that he looked almost like a hedgehog; but in the Renaissance, with the revival of interest in the art of classical antiquity and in the depiction of the nude, the number of arrows was drastically reduced, and the beauty of the young man's body became the focus of attention.

Mantegna's painting of 1455–60 (Fig.48) is a good example of this development. There is little to distract from the finely studied anatomy of the saint, who is portrayed with the axis of his hips sloping in the opposite direction from the axis of his shoulders, an arrangement of the body (called *contrapposto*) that was devised in classical antiquity in order to give the appearance of living balance to the body. Mantegna, whose interest in antiquity went far beyond the classical pose of his figure, was careful to introduce fragments of ancient statuary into the picture and to bind the saint to a broken arch decorated in the Roman manner. In doing this he was not only indulging his own passionate enthusiasm for archaeological studies and hinting at the historical period in which St Sebastian actually lived, but he was also suggesting the ultimate spiritual triumph of Christianity over paganism, the material relics of which are shown in a state of decay.

One of the most popular subjects from the New Testament to be represented in religious painting is the *Annunciation* (Figs.49, 76 and 77). The story is told in the gospel according to St Luke:

'In the sixth month, the Angel Gabriel was sent by God to a town in Galilee called Nazareth, to a maiden betrothed to a man named Joseph ... The maiden's name was Mary. Gabriel went in to her and said: "Greetings, lady of grace! The Lord is with you."

'She was cast into confusion by his words and asked herself what this salutation might portend.

'"Have no fears, Mary," said the Angel; "for you have found grace with God. Know that you will conceive and bear a son, whom you shall call Jesus. He will be great and shall be known as the son of the Most High ..."'

Luke 1:26–32

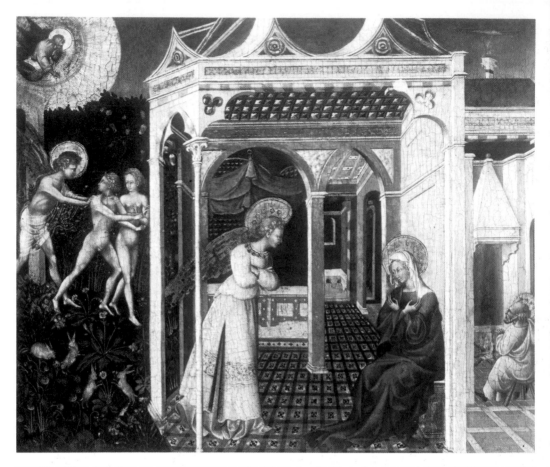

49 *Above* Giovanni di Paolo (Italian, c.1400–82): *The Annunciation*, c.1445. Wood, 15¾ × 18¼ins (40 × 46cm). National Gallery of Art, Washington DC (Samuel H. Kress Collection)

50 *Opposite left* Masaccio (Tommaso di Giovanni; Italian, 1401–28): *The Expulsion from Paradise*, c.1427. Fresco, S. Maria del Carmine, Florence

51 *Opposite right* Venus Pudica (the 'Capitoline Venus'), 2nd century BC. Marble, 73½ins (187cm) high. Museo Capitolino, Rome

Painters usually illustrated this story, as Giovanni di Paolo did (Fig.49), by showing the angel, winged and radiant, deferentially addressing his message to the Virgin Mary who is depicted as humble, devout and perhaps a little startled by the angel's sudden appearance.

To the left of Giovanni di Paolo's picture (Fig.49), in the delightful garden outside, we see two naked and dismayed figures moving rapidly off to the right, hastened on their way by a determined angel. The two figures are Adam and Eve, and the little background scene shows their expulsion from Paradise. They have committed the first or 'original' sin of eating the fruit of the tree of knowledge, which God had expressly forbidden them to do, and now, having forfeited their right to dwell in the Garden of Eden, they are being expelled from it.

The reason why this scene appears in the background of a painting of the Annunciation is because Christ, whose imminent birth is here foretold, will eventually give his life to redeem mankind from Original Sin. God the Father in the upper left-hand corner of the

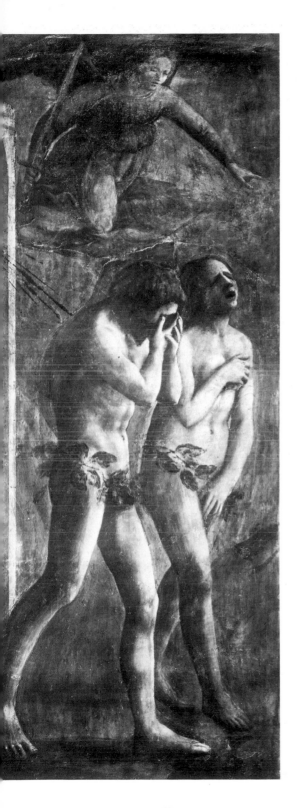

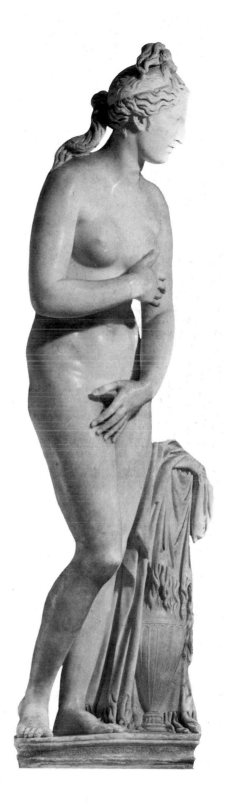

picture directs the scenes below – the Expulsion of mankind from Paradise after the Fall, and the ultimate salvation that will come through the suffering and sacrifice of his son Jesus.

Of the numerous representations of the *Expulsion*, perhaps the most powerful of all is the one painted by Masaccio around 1427 (Fig.50). Adam covers his face and is bowed under his shame, while Eve howls her despair in an agony of remorse. It is not immediately obvious that this deeply moving picture is an early example of that interest in classical antiquity and the portrayal of the nude which were developed more fully later in the fifteenth century, by Mantegna (Fig.48) among others, but a closer look reveals that the figure of Eve is actually based on the antique type of figure known as the Venus Pudica (Fig.51) most expressively transformed by few, but telling, modifications.

The *Nativity* is the title given to paintings which show the new-born Christ adored by his mother (Fig.52). Joseph, Mary's husband, is usually also present, together with two animals: the ox and the ass. Joseph's presence is easy to explain, but the reason why the ox and the ass are such a standard part of the picture is more obscure. The gospel according to St Luke (2:7) explicitly states that when Jesus was born, Mary wrapped him in swaddling clothes and laid him in a

52 Hugo van der Goes:
The Portinari Altarpiece
(*The Adoration of the
Shepherds*), c.1475.
Height 99½ins (253cm);
total width including
side panels 234ins
(594cm). Uffizi, Florence

manger, because there was no room at the inn – but no animals are
mentioned. The ox and the ass do appear, however, in the book of
Isaiah in a passage that was considered prophetic of the coming of
Christ:

'The ox knoweth his owner, and the ass his master's crib . . .'

Isaiah 1:3

Once again we see how parts of the Old Testament enter into the
background of the thinking that goes into illustrations of the New
Testament – and sometimes even physically into the background
of the pictures themselves.

The painting by Hugo van der Goes (Fig.52) shows more than just
the Nativity, for it also illustrates the Adoration of the Shepherds.
According to the gospel of St Luke:

'In the neighbourhood there were some shepherds living in the fields and
taking it in turns to watch their flocks by night. To them an Angel of the
Lord appeared . . . they were overcome with awe. But the Angel said:
"Have no fears; for I bring you good tidings, news of a great joy which
the whole people will share. Today in David's town, there has been born
for you a saviour, who is Christ the Lord. Known by this token – you will
find a babe in swaddling-clothes lying in a manger."'

Luke 2:8–12

The shepherds then went to find the Child and, in the company
of many angels, worshipped him.

Hugo van der Goes has shown the shepherds approaching the
Holy Family from the right, their hurried gestures touched with
intensity and awe. Mary kneels to the left in solemn adoration of the
Child who lies, isolated in splendour, in the centre of the picture.
A bevy of small angels, elegantly attired in rich finery, hover around
the scene and join in the worship of the infant Saviour. Hugo has
tellingly contrasted the angels, gorgeously draped in silk tunics and
heavily embroidered cloaks, with the rough clothes and common
features of the shepherds, simple men touchingly moved to piety by
the sight of the Holy Child bathed in radiance.

This altarpiece was commissioned by Tommaso Portinari, who
had the painter include portraits of himself and his family devoutly
praying on the wings in the company of their patron saints (cf.
Fig.16).

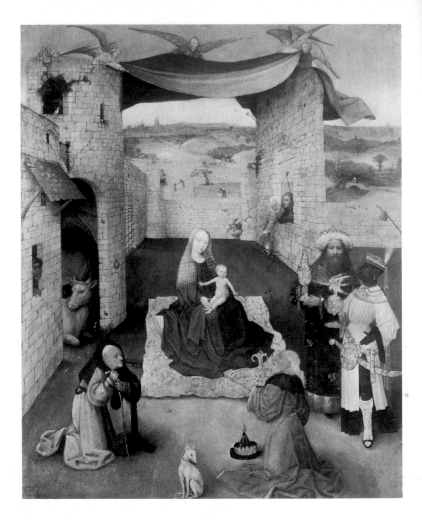

53 Hieronymus Bosch
(Flemish, c.1450–1516):
*The Adoration of the
Magi*, c.1490. Tempera
and oil on wood, 28 ×
22¼ins (71 × 56.5cm).
Metropolitan Museum
of Art, New York
(Kennedy Fund, 1912)

Angels announced the birth of Christ to the simple shepherds, but some 'Wise Men' from the East saw a star rise and understood for themselves what it betokened. They travelled to Bethlehem and

'. . . found the Child with his mother Mary. They prostrated themselves and did homage to him; they opened their caskets and laid before him gifts of gold and frankincense and myrrh . . .'

Matthew 2:11

In paintings illustrating this story, the Wise Men are usually three and they are commonly referred to as 'the Magi'. Artists painting the *Journey of the Magi* often showed them accompanied by a rich and varied entourage, including exotic animals and people. The *Adoration of the Magi* was also a popular theme. Having reduced the number of Magi to three, painters tried to vary their characters to suggest that these three were universally representative. Thus they

62

usually showed one of the Magi young, another mature, and the third old. Often two of the Magi would be European types and the third African. This is how Hieronymus Bosch has shown the Magi in his painting of the scene (Fig.53). The elderly, white-haired, white-bearded Magus, despite his venerable age and dignity, humbly kneels before the Holy Child to offer his rich present. To the right stand the mature Magus and his youthful black companion, waiting their turn to pay homage to the Child and give the precious gifts they have brought. Joseph is on his knees to the left in front of the stable where the ox kneels, and the ass is seen only from the back. In the centre is the Madonna holding the baby Jesus on her lap. She is seated on a cloth of gold which indicates that despite the modest setting she is the Mother of God.

The gospel according to St Mark begins with a description of how John the Baptist came as a messenger to the people to prepare the way for Christ. Many people came to him seeking forgiveness for their sins and the baptism of repentance.

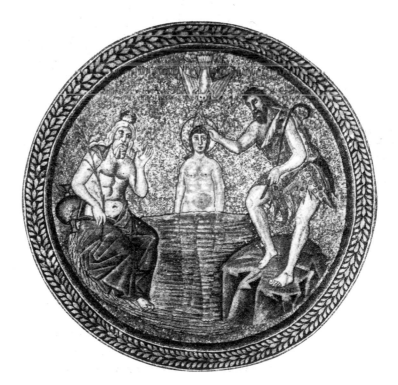

54 *The Baptism of Christ*, central tondo from the dome of the Baptistery of the Arians, Ravenna. Mosaic, 6th century

55 Matthias Grünewald (German, d.1528): *The Crucifixion*, central panel of the Isenheim Altarpiece, c.1510–15. 96 × 121ins (240 × 300cm). Musée Unterlinden, Colmar

'He preached in these words: "He is on his way. One greater than I comes after me, whose sandal-straps I am not fit to stoop down and undo. I have baptised you in water; but he will baptise you in the Holy Spirit."

'And now Jesus appeared, coming from Nazareth in Galilee, and was baptised by immersion in the Jordan at the hands of John. He had no sooner come up out of the water than he saw the heavens rent asunder and the Spirit descending like a dove towards him. There was a voice too from the heavens: "Thou art My son, the Beloved One. In thee I rejoice."'

Mark 1:7–11

The Baptism of Christ is shown with admirable clarity in the dome of a building that was itself a baptistery in Ravenna (Fig.54). Jesus stands in the centre immersed almost to his waist in the waters of the river. John the Baptist, wearing his characteristic hair shirt, has just reached out to baptise him, and in that instant the Holy Spirit in the form of a dove has appeared, and is seen above Jesus' head. To the left sits a classical figure type, a personification of the River Jordan, suitably awed by the miracle that has taken place in his waters.

64

56 *Crucifixion* from the Monastery Church at Daphne. Mosaic, 11th century

After he had performed many miracles, Jesus came to Jerusalem. There, he celebrated the Jewish Passover amidst his disciples, sharing with them his last supper before he was betrayed (cf. Fig.98, p. 106). It was at the Last Supper that Jesus instituted the sacrament of the Eucharist (Fig.80).

Artists were often asked to paint pictures of the Last Supper on the end walls of monastic refectories, so that while the monks or nuns dined below, Christ and his disciples would seem to be with them 'at the high table'. Such are Castagno's and Leonardo's paintings (Figs.78 and 79), the design of which we will discuss more fully later.

After the meal had ended, Jesus went out and spent the night in prayer, for he knew that at dawn he would be betrayed. Indeed Judas had already arranged to identify Jesus to those who came to arrest him by singling him out with a kiss (cf. Fig.98).

The Crucifixion itself, Jesus' acceptance of a hideous death for the sake of the salvation of others, presents the central image for

Christian faith. Artists thought and rethought how they should paint this all-important event. Some tried to convey the extreme physical agony that Christ had to endure, as in Grünewald's heart-rending image (Fig.55). Jesus' head drops forward, his face exhausted by pain; the poor body is torn and bruised, from the piteous feet (cruelly nailed together) to his anguished fingers, clawing hopelessly at the air. To the left, the Madonna collapses into the arms of St John the Evangelist, while the grief-stricken Mary Magdalene (who was passionately devoted to Christ) kneels at the foot of the cross. On the right, St John the Baptist is shown calmly pointing out that he who died on the cross is the true Saviour. St John the Baptist was not in fact present at the Crucifixion, having been beheaded long before. His presence here is symbolic, and alludes to his role as the one who foretold the coming of Christ.

Other artists hint rather at the spiritual meaning behind the ordeal of the Crucifixion, as did the designer of a mosaic in the eleventh century (Fig.56). Here, Christ's body shows no signs of physical suffering but for the gash in his side, which is in accordance with St John's gospel (19:33–37). This artist wishes to reveal the fulfilment of the Scriptures rather than to re-create a historical scene. There is quiet sorrow and devotion expressed in the flanking figures of the Virgin Mary and St John. Between them, Christ is shown in all his beauty of spirit and form, transcending the ordeal of Crucifixion.

'It was now late in the day, and . . . Joseph of Arimathaea . . . asked . . . for the body of Jesus . . . Joseph bought some linen, took him down from the cross, wrapped him in the linen and laid him in the tomb . . . Mary Magdalene and Mary the mother of Joses observed the spot where he was laid.'

Mark 15:43–47

Thus does St Mark describe the entombment of Christ, a pathetic subject that was often depicted very movingly by artists. Caravaggio (Fig.57) has shown the scene with grave and touching simplicity. Two men gently lower the limp body of Christ (the gospels differ in their accounts of exactly who was present at the time) while three lamenting women stand behind the men. The linen used to wrap the body hangs below Christ's dangling right arm. From this lower left-hand corner of the picture the forms in the painting move up towards the upper right in a crescendo of grief, ascending from

57 Caravaggio (Michelangelo Merisi da Caravaggio; Italian, 1571–1610): *The Entombment*, 1602–3. 118 × 80ins (300 × 203cm). Vatican, Rome

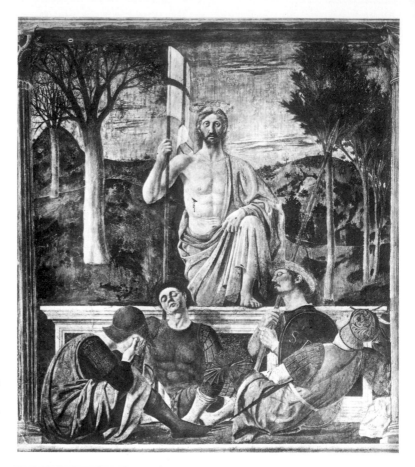

58 Piero della Francesca
(Italian, c.1420–92):
The Resurrection, c.1463.
Fresco, Pinacoteca
Civica, Borgo San
Sepolcro

Jesus' impassive face, through the sorrowing men and the two
tearful women, to reach a climax in the despairing gesture of the
woman furthest back.

None of the gospels describes the Resurrection. They only state
that three days after the Crucifixion, Christ's tomb was found to be
empty. But artists tried to imagine, and convey, what it must have
been like when Christ rose from the dead. Images of the Resurrec-
tion are very varied. Some show Christ soaring up from the tomb in
a blaze of light; others show him emerging more sedately. Extra-
ordinarily original in its power and grandeur is the *Resurrection*
painted by Piero della Francesca around 1463 (Fig.58). The massive
figure of Christ stands boldly in the centre of the painting; he looks
straight ahead at the worshipper. He pauses as he steps out of the
grave; there is no need to hurry, for the banner of salvation that he
carries is for all eternity. To the left, the tree is dead, the land
barren; to the right, everything has burst into leaf. The guards who
are sprawled in the foreground still sleep. The miracle is accom-
plished silently with magnificent inevitability.

7 Pictures as decorations on flat surfaces

59 Henri Matisse
(French, 1869–1954):
The Red Room, 1908–9.
71 × 97ins (180 × 246cm).
Hermitage, Leningrad

Once when a lady was visiting the painter Matisse in his studio, she remarked 'But surely, the arm of this woman is much too long!' Matisse replied politely 'Madame, you are mistaken. This is not a woman; this is a picture.'

A picture need not be identical with the world we see. It can, for instance, be much more decorative, as Matisse himself has shown in a painting like *The Red Room* (Fig.59). One can recognise the

60 Torii Kiyonobu I
(Japanese, 1664–1729)
(attrib.): *Dancer*, c.1708.
Woodcut, 21¾ × 11½ins
(55 × 29cm).
Metropolitan Museum
of Art, New York
(Harris Brisbane Dick
Fund, 1949)

elements in the picture – the elegantly laid table, the neat maid, the lively tablecloth and wallpaper, a chair, a window and a view beyond of trees and grass with a house in the distance. But the way Matisse has painted it is not the way the world looks – and why should it be? Is not the delicious play of patterns much more enjoyable and perhaps even more appropriate for the decoration of a flat surface?

Japanese woodcuts are often masterpieces of harmonious two-dimensional design. For example Fig.60 shows a dancer. It is not difficult for us to find her head, her left hand and even her tiny foot peeking out from beneath her dress, but what really catches our attention is the graceful movement that is conveyed by the swirling kimono, and the spectacular way in which the bold and elaborate

70

decoration of the material has been resolved into a pattern of un-expected complexity and charm.

Harmony of line and colour – flat pattern decorating a flat surface (as in Figs. 59 and 60) – need not be tied to representation. Elaborate permutations in abstract design have been explored by Islamic artists, for though the religious ban in Islam on the representation of living creatures has never been strictly enforced, it was influential enough to stimulate a long tradition of non-representational art. The main field of decoration on this page in the Koran (Fig. 61) has been broken up by interlocking straight-sided shapes. The regularity and radial symmetry of the design suggest that some complex mathematical system underlies the pattern. The interstices are filled with decoration, tight geometric patterns on gold; freer, bolder ones in the larger segments on a blue background. A looser, more organic, almost floral intertwine frames the primary rectangle on three sides. Finally, delicate little spiky finials project into the border. The decoration is most rigidly controlled at the centre and seems to become freer as it moves to the edges.

A page from a book of gospels decorated around 700 AD in the British Isles (Fig. 62) looks very different despite the fact that here too the decoration is all-over, non-representational and divided into sections by geometrical shapes. In this case the dominant geometrical shape is the Christian cross. It lacks the radial symmetry of the Islamic design, but compensates for this by its religious associations. The great cross dominates the centre of the field, which is otherwise covered by a network of decoration made up of a teeming mass of intertwined creatures. Larger elements seem to seethe around the outside of the cross (none of them so bold as those on the Koran page), smaller ones within it; the cross itself imposes order on these otherwise somewhat monstrous, almost organic shapes.

Though flat, these two designs (Figs. 61 and 62) are immensely complex, and full of exquisite detail that must have required the most extraordinary manual dexterity. By contrast, the paintings of the twentieth-century Dutch artist Mondrian are starkly simple, made up of large blocks of primary colours (red, yellow and blue) on a white ground separated by black lines that cross at right angles (Fig. 63). Although Mondrian's paintings were not in the service of conventional religion, as were the book illuminations of the Koran and the gospels, he was still looking for something more profound

61 *Above* Page from a Koran (MS Or 848 fol. lv). 14th century. 10 × 7¼ins (25.5 × 18.7cm). British Library, London

62 *Above right* Page from the Lindisfarne Gospels, c.700. 13½ × 9¾ins (34 × 25cm). British Library, London

than mere decoration in his careful balancing of areas and colours. He hoped that by reducing the elements in his paintings to the essentials – eliminating mixed colours and curves – he could arrive at universal statements devoid of subjectivity. He did not arrange the elements in his paintings according to a regular geometrical framework, as did the book illuminators, but found balance and harmony through a particularly sensitive arrangement of large blocks of solid colour.

While Mondrian sought maximum contrast in the colours he used, Josef Albers instead chose to explore subtle relationships of colour. Like Mondrian, in working on what almost seem to be visual experiments, he kept the number of variables strictly limited. Thus in works like the study for *Homage to the Square* (Fig.64) he made use of only one pure geometrical shape, the square, and a restricted but closely related range of colour.

Pictures are almost always on flat surfaces; it is therefore perhaps surprising how seldom this basic fact has been stressed by artists. Certainly as soon as elements of representation appear – even such abstract ones as we see in Matisse's *Red Room* or the Japanese *Dancer* – there is some suggestion of volume and depth. Only rarely have artists devoted themselves single-mindedly to making patterns intended purely as enhancements of flat surfaces.

63 *Above* Piet Mondrian
(Dutch, 1872–1944):
*Composition with Red,
Blue and Yellow*, 1930.
20 × 20ins (50 × 50cm).
Collection Mr and Mrs
Armand P. Bartos, New
York

64 *Right* Josef Albers
(American, German-
born, 1888–1976): Study
for *Homage to the Square
(Departing in Yellow)*,
1964. 30 × 30ins
(76 × 76cm). Tate
Gallery, London

73

8 Tradition

In 1965 Roy Lichtenstein painted this picture (Fig.65). At first sight it is very puzzling. It seems to be merely the representation of a few very free and expressive brush-strokes. To the right there are what look like some splodges, as if the brush used was so heavily loaded with paint that some of the paint had dripped off it before it touched the canvas.

An odd subject, you may think, and still odder in the way it is painted, for Lichtenstein himself has used anything but free and expressive brush-strokes. Instead he has been most careful and precise in the way he has executed his painting.

What is it all about?

It is, in fact, an artist's comment on art. In order to understand what Lichtenstein is getting at, one has to look at art in the generation preceding his own. At that time a style called 'Action Painting' was much admired. The Action Painters wished to convey to the spectator the actual activity of painting, to invite him vicariously to participate in the physical experience of the painter. Jackson Pollock

65 *Below* Roy Lichtenstein (American, b.1923): *Big Painting No. 6*, 1965. 92½ × 129ins (234 × 328 cm). Kunstsammlung Nordrhein-Westfalen, Düsseldorf

66 *Below right* Franz Kline (American, 1910–62): *Vawdavitch*, 1955. 62 × 80ins (157 × 203 cm). William Rockhill Nelson Museum, Kansas

(Fig.4) tried to achieve this by dripping, throwing and splashing paint onto a canvas lying on the floor. The final result not only presents a pleasing pattern, but also records the vigour and action of the painter's body as he worked on the picture. Other painters in the same artistic movement used other techniques and produced results that look rather different. Franz Kline, for instance (Fig.66), worked in a more conventional manner with a brush – but it was a big brush, heavily loaded with paint. He used it freely, tracing bold strokes across a huge canvas, evoking in the viewer a sense of his own action as he made the painting. And it is of course just this sort of work, in which the action of the artist is the subject of the painting, that Roy Lichtenstein seems to be making fun of.

We may or may not like his joke once we have understood it, but it is clear that we must have some knowledge of his background – of the tradition he emerged from and was reacting against – if we are to understand his work at all.

Artists do not create in a vacuum. They are constantly stimulated by other artists and by the artistic traditions of the past. Even in reacting against tradition, artists show their dependence upon it. It is the soil from which they grow and from which they take nourishment. This they know and freely admit; even Lichtenstein has said '. . . The things that I have apparently parodied, I actually admire.'

The greatest and most original artists, even the most astonishing innovators, are deeply sensitive to tradition.

Take Picasso, for example. We have seen the remarkable range of his work – the expressive distortions that give such power to *Guernica* (Fig.40); the delicate realism of his drawing of Vollard (Fig.22); his penetrating revelation of the feelings behind a child's taking her first step (Fig.28); the formal innovations shown in his Cubist portrait (Fig.21). For all his immensely fertile and original mind, he also came back to refresh himself at the wellsprings of tradition. Thus in February 1960 he turned once again to a famous painting of Manet's for inspiration. Manet's *Luncheon on the Grass* (Fig.67) showed two women (one nude, one in a shift) and two clothed men in the woods by a stream enjoying a picnic. Picasso's first painting on the theme (Fig.68) is a fairly straightforward copy of Manet, at least as far as the number and placement of the figures go, though the style is of course markedly different. This painting

67 *Top* Edouard Manet (French, 1832–83): *Luncheon on the Grass*, 1863. 84 × 106ins (213 × 269cm). Louvre, Paris

68 *Above right* Pablo Picasso: *Luncheon on the Grass*, 27 February 1960. 45 × 57ins (114 × 146cm). Musée Picasso, Paris

marks neither the beginning nor the end of Picasso's involvement with this theme. The previous August he had made six drawings after Manet's *Luncheon on the Grass*. The oil painting (Fig.68) was the first of a series; he made two more the next day, and a fourth on the day after that. He began reworking details, modifying elements (Fig. 69), sometimes even recasting the whole composition. By 1963 he had produced 27 oil paintings and over 150

drawings based on Manet's famous original.

Manet's painting (Fig.67) itself caused a sensation when it was exhibited in 1863 and was considered quite revolutionary. But although Manet had painted the work in his own style he too had drawn the idea from tradition. Three of his four figures are based on part of an engraving (Fig.70) made in the sixteenth century, a copy of a composition (now lost) by Raphael. It represented a group of

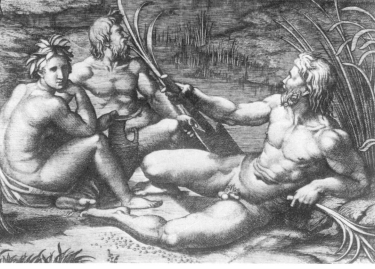

69 *Above right* Pablo Picasso: *Luncheon on the Grass*, 23 March 1963. Crayon on book end-papers, $14\frac{1}{2} \times 21$ ins (37×53.2cm). Private collection, New York

70 *Right* Marcantonio Raimondi (Italian, c.1488–1530): Detail from *The Judgement of Paris*, engraving after Raphael, c.1520. Metropolitan Museum of Art, New York (Rogers Fund, 1919)

71 Detail of a Roman sarcophagus showing river gods, 3rd century AD. Villa Medici, Rome

river gods who were incidental figures in an illustration of the Judgement of Paris (cf. Figs.45 and 46). Though Raphael's work has disappeared, the engraving is accurate enough to reveal that Raphael himself, like other great artists, gratefully drew on tradition, for his river gods are clearly inspired by the mutilated fragments of a sarcophagus relief (Fig.71) that he must have seen and studied in Rome.

There are of course dozens, indeed hundreds, more examples in which artists have obviously been influenced by their predecessors and have drawn on the rich tradition of Western art – not merely for the subjects of their pictures but also for the poses assumed by various figures, the techniques used for suggesting space, the effects of light and shadow, the arrangement of objects and many other features that entrance the eye or intrigue the mind of the onlooker. Although it is not essential for us to know about all these traditions in order to enjoy looking at pictures, our pleasure is often enhanced and deepened if we do.

9 Considerations of design and organisation ·

One look at a picture is enough to give us some impression of it. Henry VIII (Fig.72) immediately appears to us grand and domineering; Lady Brisco (Fig.73) the epitome of elegance. It is often much more difficult to say just why we have formed the impression we have, or how the artist has produced his effects. Even if one spends a long time looking at a picture, it is not easy to find words to describe what one is seeing or discover concepts that help with understanding.

Sometimes it is useful to try to look at a picture in terms of forms and colours, shapes, sizes and arrangements – trying, momentarily, to ignore the actual subject. In this way one can see that the figure of Henry VIII (Fig.72) fills a great deal more of the picture than does the corresponding figure of the delicate Lady Brisco (Fig.73). Henry's feet are spread wide, his shoulders are broader still; there is very little space in the picture on either side of his elaborate sleeves. No wonder he gives an impression of massiveness – the painter has suggested that once he is present he fills the room.

Lady Brisco (Fig.73), by contrast, occupies less than half the width of the picture Gainsborough has painted of her. There is plenty of space to the right for the friendly dog to gambol and a waterfall to purl through a wide landscape, in which the graceful lines of a slender young tree pleasantly echo the form of the lady herself.

Henry VIII is painted with firm outlines, bold colours and careful brushwork that rounds the forms clearly and delineates exactly the many details of his gorgeous costume. The portrait of Lady Brisco is painted with a much freer brush: using pale, cool colours the artist has caught the shimmer of silk, the sheen of taffeta, the downiness of the feather rather than any precise details of dress and hat. The outlines melt imperceptibly into the surroundings or background. The lively brush-strokes in the cloud-streaked sky also contribute to the sense of spontaneity and informality; behind Henry there is no vista, just brocaded curtains and green marble

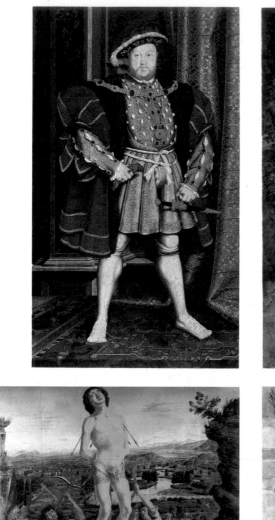

wall, their carefully rendered richness reinforcing the impression of formal grandeur.

Once we begin to notice how large or small a figure is in relation to the frame of a picture and to observe whether the brush-strokes depicting it are meticulously controlled or apparently light and free, we can begin to understand how a painter may be able to create the effect of dominating magnificence or suggest the impression of casual elegance.

A single figure presents fewer problems of design to a painter than a group. When in 1475 Pollaiuolo painted the martyrdom of St Sebastian, he had to think about how to make the story clear and convincing and how, at the same time, to make the picture balanced and harmonious (Fig.74). To ensure that the saint was immediately recognised as the most important figure, he placed the scene on a hill from which a long view of distant landscape and sky was visible, and against this background painted the saint's pale body with beautiful simplicity and clarity. The horses, trees, buildings and armed men in the landscape stretching away beyond the hill are relatively small and dark in contrast to the figure of the saint. St Sebastian, high up in the picture, towers over his tormentors. There are six of these, and though they seem at first glance to be casually arranged, a closer look reveals that their poses are carefully calculated to balance one another: the two figures in the middle foreground are back and front views of virtually the same pose, and this principle of reversal has also been applied to the flanking archers in the left and right corners. The bowmen form a menacing circle around the saint; he has been made, in every way, the centre of attention.

Raphael had to consider similar problems of organisation about 40 years later, when he decorated the wall of a private house in Rome with a fresco painting showing the sea-nymph Galatea riding in a shell-chariot drawn by dolphins and surrounded by other minor pagan divinities (Fig.75). Like Pollaiuolo before him, Raphael wanted to make sure that interest was focused on his central figure, and he has succeeded, though in a very different way. Galatea is neither placed high in the picture nor clearly isolated from the two tangled groups of three figures on each side of her – and yet she is the one who immediately catches the eye. This is largely because of the bright red length of billowing drapery that curls round her body

and blows off to the left; it is the strongest colour in the picture.

Raphael's painting looks freer and more relaxed in its organisation than Pollaiuolo's. In particular the central figure of Galatea is impressive for its sense of vitality and harmony. Much of this results from the fact that although the lower part of the nymph's body and her head turn to the left, the upper part of the body and the arms turn to the right, so that movement is balanced by counter-movement. But, on the whole, the devices used by the two artists are not all that different. In Raphael's painting three cupids circle in the sky, aiming their shafts of love at Galatea; the arrows pointing towards her help to focus the spectator's attention on the nymph. The flying cupids to the right and left are shown reversed (front and back view), much like Pollaiuolo's archers; the cupid at the top is balanced, perhaps less obviously, by the cupid skimming the water just below Galatea's chariot.

Learning to recognise the means that artists have invented to achieve particular effects helps us to understand a little better why certain pictures impress us the way they do. Our appreciation of works of art can often be enhanced by formal analyses, like those suggested for Figs.72–75, which allow us to discover how much care and subtle thought painters have to employ in order to create what seem to be perfectly natural pictures.

10 Problems in the depiction of space

Certain problems have presented a sustained challenge to artists; one of these is the representation of a plausible space on a flat surface.

Painters were not always concerned to do this. For instance, the artist who painted the picture of the Annunciation in a German missal around 1250 (Fig.76) did not really care whether the symbolic house in which he placed the Virgin Mary looked large enough to accommodate her comfortably or whether there appeared to be enough space within the arch through which the angel must be supposed to have passed, leaving part of his wing and cloak flying out behind.

But the depiction of measurable space became a burning issue in the Renaissance. During the first half of the fifteenth century the architect Brunelleschi formulated the rules of single-point perspective and the versatile Alberti popularised them in his treatise *On Painting*, explaining in relatively simple terms how an artist ought

76 *Below The Annunciation*, page from a German Missal, c.1250. 6 × 4¾ins (15 × 12cm). Metropolitan Museum of Art, New York (Fletcher Fund, 1925)

77 *Below right* Fra Angelico (Italian, c.1401–55): *The Annunciation*, c.1440–50. Fresco, Museo S. Marco, Florence

78 Andrea del Castagno
(Italian, c.1421–57): *The
Last Supper*, c.1445–50.
Fresco, Sant' Apollonia,
Florence

to go about constructing his picture in accordance with these rules.
The result of using his system is that architecture can be represented
convincingly. The effect is both rational and consistent, and we can
appreciate at once the influence of Alberti's treatise if we look at Fra
Angelico's setting for his *Annunciation* (Fig.77), painted about a
decade after the book's publication. The portico is solid, the figures
three-dimensional; we know just how far under the loggia Mary is
sitting and can see how the tip of the angel's wing grazes the far side
of the foreground column. All this could now be taught and learned;
that Fra Angelico in addition infuses the scene with serenity and
stillness is the mark of his particular genius.

Rationalising the representation of space was a great triumph for
the artists of the early Renaissance (the fifteenth century). They
rejoiced in their mastery and sometimes brought off virtuoso per-
formances in which the picture appeared to be a real extension of
the room it was made for. This is what Andrea del Castagno has
done in his *Last Supper* (Fig.78) painted for the convent of Sant'
Apollonia around the middle of the fifteenth century. Castagno has
set the scene in what looks like a richly panelled alcove added to the
back of the refectory in which the nuns had their meals. He has
tried to make everything as vivid as possible and has even chosen a
low point of view (we do not see the top of the table, but look up
towards the ceiling) to correspond to what the real position of a 'high

84

table' would be. Naturally, in order to be consistent, he has made things that are closer to us larger.

This insistent realism, however, is not without its drawbacks, for the largest person in the picture (and consequently the most eye-catching) turns out not to be Christ, but the traitor Judas.

Christ and his disciples are placed on the far side of the table, facing (and perhaps thus thought to be blessing) the nuns in the refectory. Judas is segregated on the other side of the table and has his back turned to the nuns. It is all completely logical; but sometimes logic, far from solving artistic problems, creates them.

The phenomenally inventive Leonardo da Vinci appreciated this, and when in 1495 he began to paint *his* version of the Last Supper, similarly placed on a refectory wall (Fig.79), he reconsidered the whole presentation profoundly.

We take in the entire scene at a glance. Christ is in the centre, framed by the window behind him, with all the receding straight lines of the architectural perspective converging on his head. He is utterly isolated from his neighbours both spatially and in his silence, which contrasts eloquently with their agitated talking. The apostles do not sit like so many pegs in a row, but are clustered

79 Leonardo da Vinci (Italian, 1452–1519): *The Last Supper*, c.1495–8. Mural (before restoration), 180 × 348ins (457 × 884cm). S. Maria delle Grazie, Milan

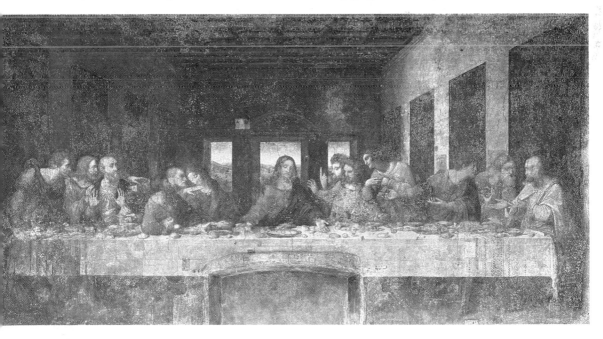

together in groups of three. Their intense excitement is caused by Christ's announcement:

'One of you is going to betray me.'

John 13:21

He is perfectly still after this statement, his stillness accentuated by the equilateral triangle formed by his head and outstretched arms. The disciples rise from their seats, gesture violently, or passionately protest their innocence, startled by his words – the whole scene has suddenly leapt into life, unified by a single dramatic impulse. Judas (fourth from the left) sits on the same side of the table as everybody else, but is still differentiated from the others, for as St Peter darts forward and leans against him from behind, he is pressed against the table with his head turned away from us, his face in shadow. This masterpiece, with its clarity and its drama, has transcended mere naturalism. The space recedes too abruptly, the table is too short (there would not be room for all the apostles should they try to sit down); but this is the most memorable and satisfying version of the scene ever painted.

Towards the end of the next century (in the 1590s) Tintoretto painted another moment in the Last Supper (Fig.80) – the institution of the Eucharist. Christ is not calmly seated, but moves around among the apostles giving to each the holy sacrament. By the time of Tintoretto, perspective constructions were taken for granted. This painter could bring off any effect he chose, however unexpected, and so instead of placing the table parallel to the picture plane, as artists had usually done before him, he put it at an angle receding obliquely away from us. From this novel and surprising point of view the servants (front right) are larger than the apostles at the table, and Christ himself, almost at the far end of the table, is greatly diminished by the perspective. Yet our eyes light on him easily enough because of his brightly shining halo; and only then do we begin to notice that despite the peculiar representation of space, Christ still remains in the centre of the picture (that is, in the centre of the physical canvas, not of the represented space).

The harmonious clarity of Leonardo apparently did not appeal to Tintoretto. He had other artistic aims. Look, for instance, at his painting *The Miracle of the Loaves and Fishes* (Fig.81).

The story according to St John is the following:

'When Jesus looked up and saw that a great crowd was approaching him, he said . . . : "Where are we to buy bread so that these people may have something to eat?" . . . And one of his disciples . . . said to Jesus: "There is a small boy here with five barley loaves and two dried fish. But what is that among so many?"

'Jesus said: "Make the people settle down."

'There was plenty of grass there, and the men, about five thousand of them, settled down. Jesus took the loaves, and after saying a blessing distributed them among his guests. He did the same with the fish, giving them as much as they wanted.

'And when they had had their fill he said to the disciples: "Collect the pieces left, so that nothing may be wasted."

'And they collected them, filling twelve hampers with pieces from the five barley loaves left over by the men who had eaten.'

John 6:5–13

80 Tintoretto (Jacopo Robusti; Italian, 1518–94): *The Last Supper*, 1592–4. 144 × 224ins (366 × 569cm). S. Giorgio Maggiore, Venice

In Tintoretto's painting (Fig.81) it is by no means immediately clear what is going on; there is a crowd of people, much colour and

action and a feeling of the sort of excitement that might accompany a miracle. When we find Christ, we discover that he is actually in the centre of the picture, energetically distributing the loaves and fishes that will feed the multitude; but being rather far back he is relatively small and less conspicuous than the larger figures placed in the foreground.

In designing both of these paintings (Figs.80 and 81) Tintoretto has kept two facts in mind: first, that they are representations of holy stories that should look plausibly real, and second that they are patterns on a flat surface. He has, in both instances, put Christ in the centre of the flat canvas, but in making the pictures illusionistic, has had to paint this all-important, but distant, figure relatively small and so not immediately striking in appearance.

One rather imagines that the contradictions implied in having a conventionally central, but unconventionally difficult-to-spot Christ delighted rather than dismayed Tintoretto. He enjoyed putting together a visually exciting picture and using devices to indicate the representation of depth both to enhance the illusion of reality and to baffle the spectator.

Such an attitude is the exact opposite of the one that motivated the early Christians when they designed mosaics to decorate their churches and instruct the faithful (p. 8 and Fig.2). This (Fig.82) is how *they* chose to illustrate the miracle of the loaves and fishes. The mosaic designer has not tried to give the least suggestion of space or depth, but has shown Christ clearly and imposingly in the

centre, overtopping the apostles on either side as he gives them the provisions for distribution. The 'multitude' which plays such a large role in Tintoretto's painting is present only by implication, but the meaning of the miracle that is about to take place is abundantly clear.

81 *Left* Tintoretto: *The Miracle of the Loaves and Fishes*, c.1555. 61 × 160½ins (155 × 408 cm). Metropolitan Museum of Art, New York (Leland Fund, 1913)

82 *Above The Miracle of the Loaves and Fishes.* Mosaic, sixth century. S. Apollinare Nuovo, Ravenna

11 An approach to stylistic analysis:
Renaissance and Baroque contrasted

People have often tried to understand and appreciate works of art
better by means of formal analyses, that is by looking at them not in
terms of subject matter or technique, but in terms of purely formal
concepts. One of the most successful has been Heinrich Wölfflin,
who early in this century, after many years of studying High
Renaissance (late fifteenth- and early sixteenth-century) and
Baroque (seventeenth-century) works of art, distilled a number of
principles which helped him characterise the differences between
the styles of the two periods. The great value of Wölfflin's work is
that he provides us with objective and impartial categories, consti-
tuting a system within which we can articulate some of our observa-
tions – which may otherwise remain very general and imprecise.

Perhaps the most important point to note, before we actually try
to apply Wölfflin's ideas to pictures, is that the concepts he has
formulated come in pairs, and that the analytical categories he
proposes are *comparative*, not absolute.

Let us take, as an example of Renaissance painting, Raphael's
Colonna Altarpiece of about 1505 (Fig.87) and, as an example of
Baroque painting, Rubens' *Holy Family with St Francis*, painted in
the 1630s (Fig.88). They are shown on p. 97.

Wölfflin's first pair of concepts is 'linear' as opposed to 'painterly'.
By *linear* he means that all the figures and all the significant forms
within and surrounding the figures are clearly outlined, as we see is
true of Raphael's painting (Fig.87). The boundaries of each solid
element (whether human or inanimate) are definite and clear; each
figure is evenly illuminated, and stands out boldly like a piece of
sculpture.

Rubens' painting (Fig.88) is, by contrast, *painterly*. The figures
are not evenly illuminated but are fused together, seen in a strong
light which comes from one direction and reveals some things while
it obscures others. Contours are lost in shadows, swift brush-strokes
bind separate parts together rather than isolating them from one
another. In Raphael's painting the form of every figure is marvel-

lously clear; in Rubens' picture Joseph (at the far right) is barely visible, but for his face.

The next pair of concepts is *planar* and *recessional*. *Planar* means that the elements of the painting are arranged on a series of planes parallel to the picture plane. In the Raphael (Fig.87), for example, the first plane is given by the small step in front, in line with which the two male saints stand; the next is the platform of the Madonna's throne, beside which the two female saints are placed; and the last is provided by the backdrop of the cloth of honour behind the Madonna: basically three planes, all parallel.

This is very different from the *recessional* construction of Rubens' painting (Fig.88) in which the composition is dominated by figures placed at an angle to the picture plane and receding into depth. The figures sweep back from the front plane, starting with St Francis at the far left, who moves in towards the Madonna further back, with the old lady, her mother Anna, recessed again behind her on the opposite diagonal.

The principle of organisation in terms of parallel planes or in terms of receding diagonals applies to parts of pictures as well as to the whole. Just compare the placement of the two children; they are arranged in stepped planes one behind the other in Raphael's painting, while they join together in one continuous movement leading back into space in Rubens' painting.

The next pair of concepts is *closed form* and *open form*. In the *closed form* of the Renaissance picture (Fig.87) all the figures are balanced within the frame of the picture. The composition is based on verticals and horizontals that echo the form of the frame and its delimiting function. The male saints at the sides close off the picture with strong vertical accents; these are repeated by the vertical accents formed by the bodies of the female saints, and finally, in the centre, by the throne itself. Horizontal accents are provided by the steps of the throne at the bottom, which emphasise the lower boundary of the frame, and the horizontal canopy above, which terminates the painting at the top. The picture is entirely self-contained. The *closed form* conveys an impression of stability and balance and there is a tendency towards a symmetrical arrangement (though, of course, it is not rigid – notice the alternation of profile and full face on the right and left pairs of male and female saints).

In the *open form* of the Baroque painting (Fig.88) vigorous

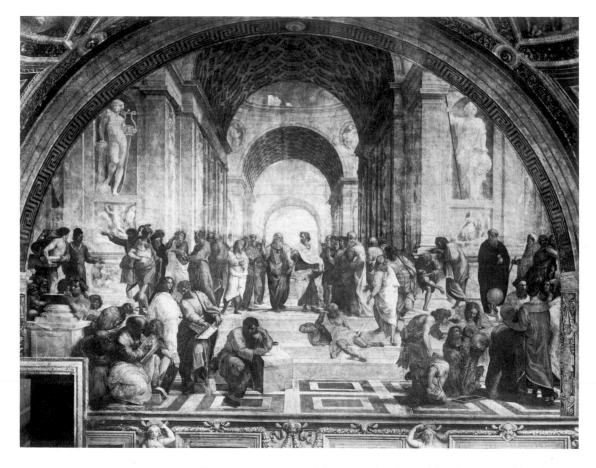

83 Raphael: *School of Athens*, 1509–11. Fresco in the Stanza della Segnatura, Vatican, Rome

diagonals contrast with the verticals and horizontals of the frame. Diagonal lines not only play on the surface of the picture, but also sweep back into the distance. Figures are not simply contained within the frame, but are cut off by it at the sides. There is a feeling of unlimited space that flows beyond the edges of the picture. The composition is dynamic rather than static; it suggests movement and is full of momentary effects, as opposed to the tranquil repose of the Renaissance painting.

Finally, *multiplicity* and *unity* form the pair of terms which is most obviously relative, for all great works are unified in one way or another. What Wölfflin means here is that the Renaissance painting is made up of distinct parts, each one sculpturally rounded in its own right, each one clearly filled with its own single, local colour, while

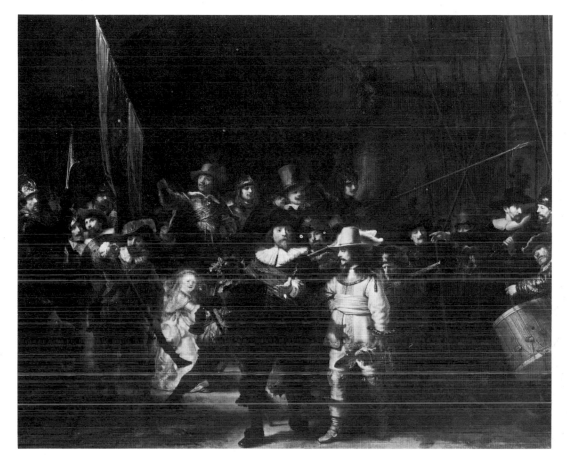

84 Rembrandt: *The Night Watch* (*The Company of Captain Frans Banning Cocq*), 1642. 146 × 175ins (363 × 437cm). Rijksmuseum, Amsterdam

the unity of the Baroque picture is much more thoroughgoing, largely achieved by means of the strong, directed light. In Fig.88 all the units – and there are very many of them – are welded into a single whole; none of them could be isolated. Colours blend and mingle, and their appearance depends largely on how the light strikes them. For instance, the Madonna's red dress looks truly red only in parts, other parts being darkened to grey in shadow, something which is much less true of the cloak of the saint to the far right in Raphael's painting (Fig.87). The even, diffused light in the Renaissance picture (Fig.87) helps to isolate elements so that a multiplicity of independent units can be balanced against one another.

You will have noticed that the various characteristics that Wölfflin has attributed to the Renaissance painting are interrelated: diffused

93

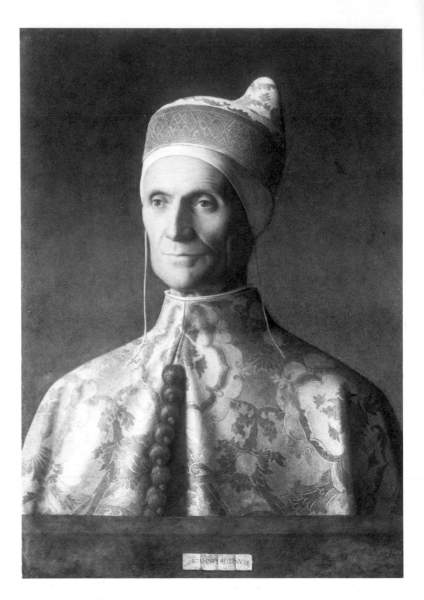

85 Giovanni Bellini
(Italian, c.1430–1516):
The Doge Loredano,
c.1501. Wood, $24\frac{1}{4} \times$
$17\frac{3}{4}$ins (61.5×45cm).
National Gallery,
London

light makes for clear outlines, sculptural modelling, isolated elements and distinct local colours. Similarly in the Baroque painting, strong unidirectional light accentuates the unity arising from the continuous character of the diagonals cutting across the surface and back into depth, blends the forms and moderates the local colours. Of course this interrelationship is really to be expected because each style is coherent, and the division into categories (*linear, planar* etc.) is only for purposes of analysis. The terms themselves are not perhaps ideal in English, but that is not very important so long as you understand what they signify.

Let us see how they apply to another pair of paintings: Raphael's

School of Athens (Fig.83) to represent the Renaissance, and Rembrandt's so-called *Night Watch* (Fig.84) – actually a very original group portrait of the sort we saw in Figs.13 and 14 – representing the Baroque. Both are large compositions made up of very many figures, but Wölfflin's principles apply excellently to them as well. Figures and elements of architecture are clear and isolated (*linear*) in the *School of Athens* (Fig.83) while they are picked out strongly in light or deeply obscured by the shadows (*painterly*) in the *Night Watch* (Fig.84). In Raphael's painting the groups of figures, and above all the whole architectural framework, with its four clearly marked steps and the sequence of arches one behind the other, are

86 Jan Vermeer (Dutch, 1632 75): *The Lacemaker*, c.1664. 24 × 21 ins (61 × 53cm). Louvre, Paris

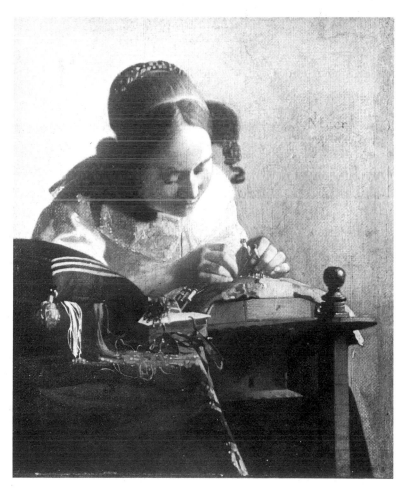

obviously *planar*, while the diagonal movement forward and to the left of the two principal figures in Rembrandt's painting and even the diagonal at which the banner is held are clearly *recessional*.

The framework of Raphael's organisation of the *School of Athens* rests on the emphatic horizontals of the steps contrasted with the verticals of the standing figures and the walls supporting the arches (*closed form*), while Rembrandt's *Night Watch* is shot through with diagonals (notice the man to the left whose rifle parallels the banner behind him and the way even the drum at the far right has been tipped so that it is not held vertically). The Rembrandt in its present form has actually been cut down, so it is hardly surprising that figures are sliced off at the edges, but even in its original condition it conformed to Wölfflin's definition of *open form*. Needless to say *multiplicity* and *unity* can be perceived as consequences of the foregoing.

Wölfflin's categories can also be applied to single figures: contrast Bellini's Renaissance *Doge Loredano* (Fig.85) with Vermeer's Baroque *Lacemaker* (Fig.86). Notice the firm horizontal sill at the bottom of Bellini's picture, the strong vertical of the erectly held head (with level eyes, horizontal mouth and vertical nose) and the bust in a plane parallel to the picture plane. Contrast these features with those of the *Lacemaker*, who sits at an angle, her further shoulder receding into depth, her head tilted so that the line of her eyes slants downward towards the left; light from the right unifies the picture by illuminating the right side and throwing the left into shadow.

Extremely telling is to use Wölfflin's technique to compare the way in which a Renaissance painter and a Baroque painter treat the same subject: Titian's (Fig.89) and Rubens' (Fig.90) *Venus and Adonis*. Venus is clinging to Adonis in both pictures, imploring him not to go hunting. In both pictures Adonis has two hunting dogs with him, and Venus has her son Cupid. Can you see how differently the same elements have been arranged and how aptly Wölfflin's criteria apply?

The value of categories like Wölfflin's lies in their objectivity. Although they were created in response to the characteristics of Renaissance and Baroque art, they can effectively be applied much more widely. For instance David's *Portrait of Madame Récamier* (Fig.91, p. 100), painted in the Neoclassical style, displays qualities

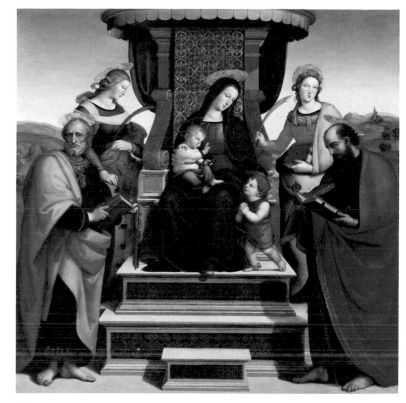

87 *Right* Raphael:
*Madonna and Child
enthroned with Saints*
(Colonna Altarpiece),
c.1505. 68 × 68ins (173 ×
173cm). Metropolitan
Museum of Art, New
York (Gift of J. Pierpont
Morgan, 1916)

88 *Below right* Rubens:
*Holy Family with St
Francis*, 1630s. 68¾ ×
82ins (175.5 × 201.5cm).
Metropolitan Museum
of Art, New York (Gift
of James Henry Smith,
1902)

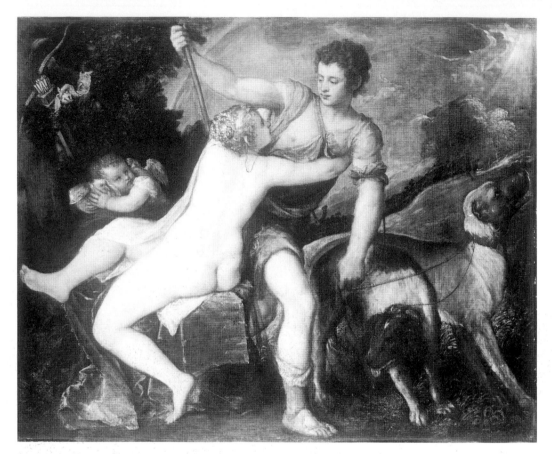

89 Titian: *Venus and Adonis*, late 1560s. 42 × 52½ins (106.5 × 133.5 cm). Metropolitan Museum of Art, New York (Jules Bache Collection, 1949)

that Wölfflin attributes to the Renaissance (which David was, to some extent, reviving in this work). The painting can be seen as *linear* in that all the forms, both of the figure and of the furniture, are clearly outlined and evenly illuminated so that they have an almost sculptural clarity. The arrangement is *planar*. Notice how Madame Récamier reclines on her couch so that she is parallel to the picture plane and how even the antique lamp on its tall slender stand is placed parallel to the same plane. The *closed form* of this austere painting contains the spare, simple forms comfortably within its borders and is accentuated by the repeated verticals (lampstand, sofa legs, lady's head) and the horizontals (footstool, sofa, antique lamp on its tray, the lady's legs and forearm) that dominate the composition.

By contrast, Fragonard's *The Swing* (Fig.92), painted in what is called the Rococo style, possesses characteristics descended from the Baroque. A strong light falls on the pretty creature on the swing; it picks out the face and arms of her admirer lying in the bushes to the left. His lower body merges into the foliage and the servant pushing the swing (to the right) is barely visible in the shadows.

98

This is a *painterly* treatment. The composition is organised in terms of *receding* forms, starting at the front on the left and moving back into the middle distance to the right. Vigorous diagonals (the pose of the admirer, the arms and hat of the lady, the ropes of the swing) cut across the canvas, while the riotous greenery is not at all confined by the frame of the picture. All these qualities are aspects of *open form*.

90 Rubens: *Venus and Adonis*, c.1635 onwards. 77½ × 94½ins (197 × 240 cm). Metropolitan Museum of Art, New York (Gift of Harry Payne Bingham, 1937)

The application of such neutral analytical categories can often sharpen our eyes and help us to perceive the structure of a work. Then we can understand better, and appreciate, how David was able to imbue his sitter with an air of serene dignity, while Fragonard could no less effectively impart a sense of liveliness and spontaneity to his charming subject.

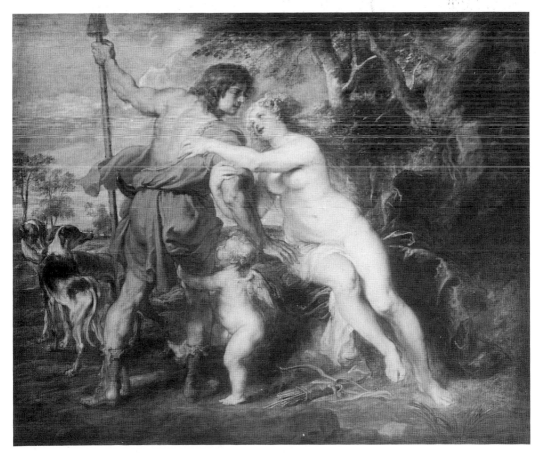

91 *Above* Jacques-Louis David: *Portrait of Madame Récamier*, begun 1800. $68\frac{1}{2} \times 96$ins (174×244cm). Louvre, Paris

92 *Right* Jean-Honoré Fragonard (French, 1732–1806): *The Swing*, 1768–9. $32\frac{1}{2} \times 30$ins (83×66cm). Wallace Collection, London

12 Hidden meanings

If you want simply to enjoy looking at a picture, you can hardly pick a better one than Jan van Eyck's double portrait of Giovanni Arnolfini and his wife (Fig.94) that hangs in the National Gallery in London. Less than a metre high, it is exquisitely painted in radiant colours and with a vast number of beguiling details.

93 *Above* Detail of the mirror from *Giovanni Arnolfini and his Bride* (Fig.94)

94 *Right* Jan van Eyck (Flemish, c.1390–1441): *Giovanni Arnolfini and his Bride*, 1434. Panel, 33 × 22½ins (84 × 57cm). National Gallery, London

The walls of the comfortable and well-appointed room are cut off abruptly by the frame; they seem to extend forward, to invite us in, to include us in the scene. We are encouraged to come closer too not only by the small scale of the work, but also by the richness of detail in the rendering of every part of it, by the softness of fur, the shine of polished metal and even the delicate carving on the woodwork. The sense of intimacy is enhanced by the subtle play of light that not only clarifies but also unites, imparting an almost mystic quality to the picture. For despite its detailed realism, there is a magic about this painting – a spirituality. One has a sense that there must be a deeper meaning behind all the apparently commonplace objects with which this pleasant interior is filled.

In fact, the painting is saturated with meaning. This is no ordinary picture of a man and a woman, but the portrayal of a religious sacrament: the sacrament of marriage. By holding the young woman's hand in his and raising his other hand in the gesture that signifies taking a solemn oath, Giovanni Arnolfini pledges himself to his bride; while she, in placing her hand in his, reciprocates in kind. This mutual oath-taking without the presence of clergy was quite adequate to serve as a marriage ceremony at that time: 1434.

Though even witnesses were not strictly necessary, witnesses were present at this wedding, and this is proven by the existence of the painting itself, which serves to some extent as a document attesting to the marriage. Above the mirror the painter testifies to his own presence at the scene by writing in florid legal script 'Jan van Eyck was here' and adding the date (Fig.95). If we look closely into the mirror, we can verify this fact, for its convex surface reflects the doorway opposite the couple and reveals that two witnesses are standing there (Fig.93).

But it is not only the scene in its entirety that is meaningful: every detail in it also has a meaning. In the chandelier, there is a lone candle burning; it is not needed for illumination in full daylight, but is there to symbolise all-seeing Christ, whose presence sanctifies the marriage. The little dog is not just an ordinary pet but represents fidelity; the crystal beads hanging on the wall and the spotless mirror signify purity while the fruits on the chest and the windowsill are a reminder of the state of innocence before Adam and Eve committed Original Sin; even the fact that the two people stand barefoot – his slippers are to the left in the foreground, hers in the centre at the

back – has meaning: it indicates that the couple are standing on holy ground and have therefore removed their shoes.

Thus one can see that the picture is filled with symbols – and there are more that we have not even noted. The symbols are not readily recognised but are disguised as perfectly natural-seeming objects. Nevertheless these disguised symbols sanctify the picture so that it is not merely a genre scene, not merely a double portrait, a secular representation of natural appearances, but the image of a deeply solemn religious moment pervaded by the presence of God.

Such disguised symbolism was characteristic of Flemish art in this period; it can be found in other works by Van Eyck and in the works of his contemporaries. Earlier pictures had been filled with explicit and unmistakable symbols. Artists in the fifteenth century wished to make more realistic images, so that it was through *disguised* symbols, such as those we have just pointed out, that they chose to elevate their study of nature into something more spiritual.

Not many paintings are like this highly remarkable one, but it is useful to remember that there can often be a great deal more to a picture than just what meets the eye.

95 'Johannes de Eyck fuit hic'. Inscription, detail of Fig.94

13 Quality

All artists have to struggle with their craft. Not only do the materials they use have awkward and sometimes unpredictable properties, but the most difficult thing of all is for artists to find a way to show in paint, charcoal, mosaic or glass exactly what they want to express in exactly the form they envisage. Success in producing a great work of art is a rare and wonderful achievement.

Artists often have tradition to help them. There were accepted ways of telling accepted stories and this meant that a painter did not always have to think out every element in a picture afresh. For instance, many painters in the fourteenth century illustrated the moving story of Joachim and Anna, the parents of the Virgin Mary. They had grown old in childlessness and were much grieved by this fact. After long suffering and much prayer, their desire to have a child was finally fulfilled. An angel came to Joachim as he was tending his flocks and told him that he would at last become a father; in the meantime another angel came to Anna while she was in her garden and told her the same miraculous news. The two elderly people, rejoicing in the unexpected answer to their prayers, hurried to find each other, and as Joachim returned from the mountains and Anna rushed from her house, they met at the golden gate of the city. This was the happy moment that painters habitually chose to illustrate.

96 *Opposite top* Taddeo Gaddi (Italian, d.1366): *The Meeting of Joachim and Anna*, 1338. Fresco, S. Croce, Florence

97 *Opposite bottom* Giotto (Giotto di Bondone; Italian, c.1267–1337): *The Meeting of Joachim and Anna*, c.1304–13. Fresco in the Scrovegni (Arena) Chapel, Padua

Taddeo Gaddi (Fig.96) gives a competent rendering of the scene: balanced, thoughtful, notably better than a run-of-the-mill representation. Joachim and Anna are virtually in the centre of the picture; they reach their hands tenderly towards each other and look deeply into each other's eyes. The city wall behind them isolates their heads, framed by haloes, while to the left the figure of a shepherd indicates that Joachim has come in from the country, and the women behind Anna show that she has just emerged from the city.

But a great artist like Giotto transforms such a conventional scene into something far more profound and moving (Fig.97). The two

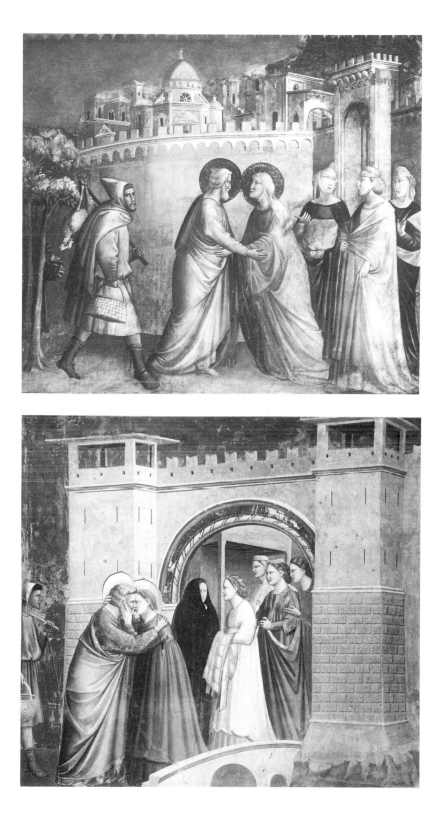

98 Giotto: *The Betrayal*
(*The Kiss of Judas*),
c.1304–13. Fresco in the
Scrovegni (Arena)
Chapel, Padua

main figures are not placed in the centre, but the lines of the composition lead our eyes inexorably to the emotional heart of the story. Gently they kiss. The curve of their warm embrace, so close that their two figures merge into a single outline, is echoed and magnified in the great arch of the city gate to the right. Even the form of the architecture enhances our appreciation of the content of the scene.

How deeply Giotto thought about the nature of this embrace is revealed by the way he portrayed another embrace in a devastatingly different scene in the very same chapel. This was the *Kiss of Judas* (Fig.98). In the meeting of Joachim and Anna, the embrace is mutual; each enfolds the other in his arms, and the gentle curve of tender encircling arms is repeated in the curves of the two intersecting haloes above (Fig.99). How different is Judas' kiss of betrayal! There is no mutuality here; the traitor engulfs in his cloak the passively enduring Christ. The two heads do not overlap but are starkly separated as a tense glance passes between the two men, both

of whom understand exactly what has happened (Fig.100). Behind them spears bristle, their sharp lines cutting across the background of sky, as eloquent of the cruel events that will follow as the arch of the gate was expressive of the harmony of the events taking place before it.

It is not simply the recognition of the different ways in which a kiss could be shown, nor the subtle enrichment of the content by the treatment of the background, nor even the brilliant idea of making these two scenes comparable as well as contrasting that makes Giotto's work so outstanding – though all these factors contribute. Sureness of hand and eye, acuteness of judgement, coupled with depth of insight and profound feeling: these are but some of the qualities that distinguish great artists from good ones.

A venerable old man, his strength waning, his eyes dim, blessing his progeny before he dies – this was the moving sort of biblical scene, full of everyday humanity, that particularly appealed to Dutch seventeenth-century painters. Govert Flinck (Fig.101) has chosen to show Isaac blessing Jacob. Actually, Isaac intended to bless his elder son, Esau, a hairy man and a huntsman, but his wife Rebecca contrived that he should give his blessing to Jacob, the younger son, instead. She 'put the skins of kids and goats upon his hands, and

99 *Below* Detail of the heads of Joachim and Anna (Fig.97)

100 *Below right* Detail of the heads of Christ and Judas (Fig.98)

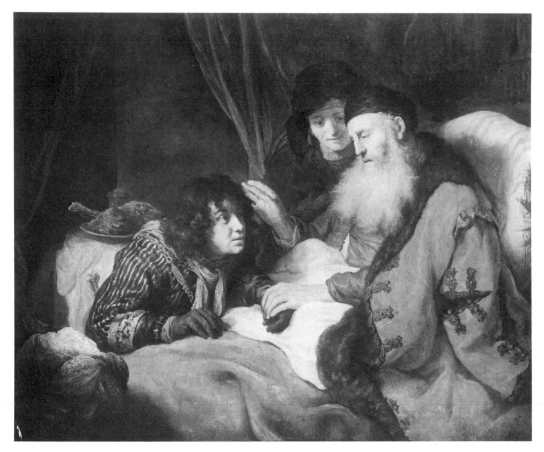

101 Govert Flinck (Dutch, 1615–60): *Isaac Blessing Jacob*, c.1638. 46 × 55½ins (117 × 141 cm). Rijksmuseum, Amsterdam

upon the smooth of his neck' (Genesis 27:16) so that when Isaac touched him, he should mistake him for the hairy Esau – and the trick succeeded. Flinck has turned the 'skins of kids and goats' into an elegant pair of gloves, a minor point in the story. He has concentrated his full artistic force on the main message – Rebecca, soothing in the background, anxious that the deception should work; Jacob, kneeling, tense and eager; Isaac, weak and nearly blind, baffled as he touches his son's hand and mutters to himself 'The voice is Jacob's voice, but the hands are the hands of Esau' (Genesis 27:22), yet resignedly raises his right hand in blessing.

A complex story, subtly told; a fine work of art, but not a great one.

Rembrandt treated a similar theme: Jacob blessing the sons of Joseph (Fig.102). Jacob himself is now old and on the point of death. He rejoices that he has beside him not only his long-lost son Joseph,

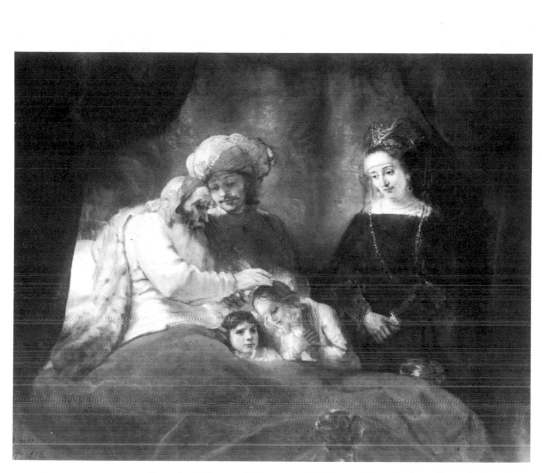

102 Rembrandt: *Jacob Blessing the Sons of Joseph*, 1656. 68½ × 83½ins (174 × 212cm). Staatliche Kunstsammlungen, Kassel

but also his two little grandchildren. He asks Joseph to bring them close so that he can kiss them and give them his blessing. He places his right hand on the head of Ephraim, the younger; Joseph, displeased, notices the mistake and 'held up his father's hand to remove it from Ephraim's head . . .' (Genesis 48:17), but Jacob knows what he is doing and insists on blessing the younger son. The story has a certain gruffness in the Old Testament:

'And Joseph said unto his father, Not so my father: for this is the first born; put thy right hand upon his head.
'And his father refused, and said, I know it my son, I know it . . .'
Genesis 48:18-19

In Rembrandt's painting it is all tenderness. With infinite tact Joseph seeks to guide the hand of the nearly blind old man; the two little boys nestle into the soft coverings of the sickbed. Their mother

stands discreetly to one side. What a wealth of humanity, of gentleness and love has been concentrated into this quiet picture!

A good painter knows how to compose his picture, has a subtle sense of colour harmonies or a bold sense of tonal dissonance, and is aware of tradition in terms both of its strengths and of its limitations. His work can give satisfaction, please, startle, enlarge our understanding of a theme or enrich our perceptions of form. But a great painter, by some miraculous gift, can open up to us a whole new world of feeling and seeing.

Index